Marlene Buck
515 Jefferson St., Apt. 205
Alexandria, MN 56308

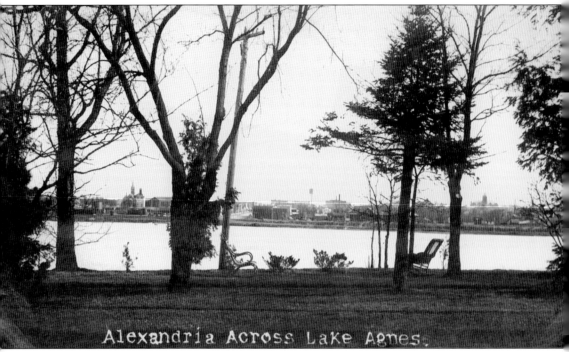

ALEXANDRIA ACROSS LAKE AGNES. In 1880, photographer N.J. Trenham wrote, "Alexandria, the county seat of Douglas County, is situated in the heart of the celebrated park region of Minnesota, on two beautiful lakes, Winona and Agnes. In Douglas County there are no less than 160 lakes, all of which are easily accessible from Alexandria; eight of which are within three miles of the village. The lakes are stocked with fish, and the purity of the water is unsurpassed, being largely supplied by springs which bubble out from the banks which surround them. Alexandria is 142 miles northwest of St. Paul, on the St. Paul, Minneapolis and Manitoba Railroad. The advantages of this section for permanent settlers, sportsmen and tourists are not surpassed in any part of the northwest." (Courtesy Douglas County Historical Society.)

ON THE COVER: HOTEL ALEXANDRIA GAZEBO ON LAKE GENEVA. Alexandria became a tourist site with the beginning of train service. The Great Northern Railway ran along the southern end of Lake Geneva, stopping at the gazebo just 500 feet from the entrance of the Alexandria Resort Hotel. (Courtesy Douglas County Historical Society.)

Barbara Grover

Copyright © 2013 by Barbara Grover
ISBN 978-0-7385-9852-9

Published by Arcadia Publishing
Charleston, South Carolina

Printed in the United States of America

Library of Congress Control Number: 2012949287

For all general information, please contact Arcadia Publishing:
Telephone 843-853-2070
Fax 843-853-0044
E-mail sales@arcadiapublishing.com
For customer service and orders:
Toll-Free 1-888-313-2665

Visit us on the Internet at www.arcadiapublishing.com

To my daughter, Carla Marie Barnhill, who taught me everything I needed to know about writing a book

Contents

Acknowledgments		6
Introduction		7
1.	Pathway to Settlement	9
2.	Trails, Trains, and Tourists	35
3.	Growing Up	55
4.	Then and Now	77
5.	Alexandria Plays, Alexandria Works	101
6.	Alexandria Remembers	117

Acknowledgments

Having lived in this community for over 50 years has been the best component for writing this book. The heart of downtown Alexandria was in our backyard, across from the county courthouse, kitty-corner from the schoolhouse. The neighborhood was comprised of families who worked and played together as the town grew around us. Many longtime good friends have contributed to the information and details that fill these pages.

I remember my mentors Minnie Osterholt and Opal Martinson from the time I served as executive director of the Douglas County Historical Society (DCHS). They both inspired me to love the pursuit of history. Minnie advised me to use a pencil, as that made it easier to correct my errors.

The thank-you list begins with Julie Blank, executive director of the Runestone Museum, who passed on an e-mail inquiry in search of an author to write a book about Alexandria. Even before I knew that I wanted to, I replied, "Yes, I'm interested." Contact with Winnie Timmons at Arcadia Publishing got the process started on the most challenging project I have ever tackled in my 78 years.

Special thanks go to museum volunteer Mike Merten, the technology guru who bailed me out and saved my files, and to Carol Meyer, proofreader and friendly counselor. A heartfelt thank-you goes to Kim Dillon and Annie Skogland, staff of DCHS, who were patient and tireless in their search through archived boxes of historical photographs and scanning and labeling the images for this book. For proofreading and double-checking historical content, thank you, Marge Van Gorp.

Time lines were easier to create with access to back issues of the local newspaper, the *Echo Press*. Historian Harold Anderson wrote useful informative articles for a special centennial celebration issue. Harold Bradley, a charter member of DCHS, created a time line of business changes from 1880 through 1980, a perfect tool to verify when and where things changed.

Freelance photographer Daniel Broten listened to my idea to capture forgotten ghosts or shadows from the past that few people are aware of or even look for. He did it with his camera's eye. Thank you, Dan.

Unless otherwise noted, images in this volume appear courtesy of the Douglas County Historical Society (DCHS).

INTRODUCTION

Telling the story of Alexandria is like putting together a giant jigsaw puzzle without all of the pieces in the box or having a picture on the cover displaying what the final image will be. The first pieces should be the border, the ones that form the basic structure and size. This starts small but keeps expanding beyond the outside edge. Many pieces remain with the same shape, color, and place in the puzzle. Some morph into a different place. Some pieces are lost, only to be replaced by new, larger, and more colorful images. The first pieces are easy.

Sioux and Chippewa Indians held the territory that became the state of Minnesota in 1858. Minnesota occupies the exact center of the continent of North America. Within the state, there are about 10,000 lakes abundant with a wide variety of fish. The rolling prairie and woods in the west central park region of the state is described as a paradise for summer idlers, hunters, and fishermen, with numerous lakes to attract the summer visitor. The shape of Alexandria was determined due to the proximity of these lakes. The settlement of Alexandria, also established in 1858, coincided with statehood.

Founders of the village were Alexander and William Kinkead, young brothers from Delaware who worked as road surveyors in the developing state and sought land for their older brother George. They found the perfect place to settle on the shore of one of those 10,000 lakes, Lake Agnes. A clear picture of those first days can be found in the book *The Kinkeads of Delaware*, which contains a chapter offering the firsthand account of Clara Janvier Kinkead, the wife of George Kinkead. She shared her story of traveling with her young family to live in an unknown wilderness, experiencing the joys and hardships of pioneer life. Her story provides details of the exodus of these settlers from the village caused by the US–Dakota War of 1862.

The second settlement, in 1866—the rebirth of Alexandria—began an exciting time of planning, development, and growth under the firm leadership of William Everett Hicks. He also was drawn to this place because of the beauty of the lakes and clear climate. The original layout of Main Street in 1880 has not changed significantly over the years. The wide main street, now Broadway, stretches north to south, and the streets are named alphabetically from west to east. Broadway is now brightly lit with five globe streetlights created from a cast of the original 1913 model. The Alexandria Airport and Industrial Park began the extension of the city limits to the south. Interstate 94 increased traffic in the same way that the railroad did in 1878. New infrastructures crisscross the puzzle, bringing people who come to live and work here or those who just come to shop or visit.

Created by an act of Minnesota State Legislature in 1971, the Alexandria Lakes Area Sanitary District (ALASD) was the third sanitary district in the state. ALASD provides sewer service to the cities of Alexandria and Nelson and six townships in Douglas County, serving a population of 22,500 with 9,646 customer accounts. The plant, which became operational in 1977, is located on the south end of Lake Winona. Formation met with some controversy and disagreement but has resulted in

improved quality of the environment and clean lakes, important for this resort and tourist town. Success was achieved with vision, strength, and conviction of forward-thinking leadership.

There are over 30 churches within the city, representing a full range of denominations. Three churches—Zion Lutheran, New Testament, and St. Mary's Catholic—support parochial schools. Social outreach is important to each congregation. Social service programs are readily available and strongly supported by the community. Care for the retirement population is given high priority, offering services such as community centers, meals-on-wheels, nutrition centers, public transportation, Lakes Medi-van, and ambulance service. Banks and insurance agencies, attorneys-at-law, and tradesmen continue to meet financial and construction needs for the rapidly growing city.

The strength of local medical services is enhanced with dental clinics, eye clinics, and veterinarians. Lowell Gess, MD, operated an eye clinic in Alexandria for 45 years, which was continued with his sons Tim and John, as well as his granddaughter Debbie. Lowell and his wife, Ruth, traveled to Sierra Leone every year to run a hospital, performing cataract surgery for the natives and fitting them with eyeglasses donated by Alexandria clients.

This puzzle will not be finished. There will be new pieces, changing pieces, the expansion of the edges with big-box stores, shopping centers, eating establishments, and hotel and motel pieces already in place. The historic Carnegie library building sits empty in the heart of downtown, just waiting for the right person with a vision to bring it back to life.

A unique piece of this puzzle is the Kensington Runestone, the key exhibit at the Runestone Museum. The discovery in 1898 of the carved stone with the runic characters tells a story of the 1362 journey of Norsemen on exploration to this area of Minnesota. The legacy of the Viking explorers is a theme used by businesses, sports teams, churches, and civic promotions throughout the state. A 28-foot-tall Viking statue, *Big Ole*, was created to accompany the Kensington Runestone to the New York World's Fair in 1965. He now stands at the north end of Broadway to welcome visitors.

The motto of the Alexandria Lakes Area Chamber of Commerce, "Easy To Get To, Hard To Leave," holds true; there was and still is a magical appeal of the beautiful landscape, the abundant lakes, and the friendly people who call Alexandria home. The 2012 population of Alexandria was 12,466.

One

PATHWAY TO SETTLEMENT

Alexandria had two beginnings. The first settlement began in 1858, the same year that Minnesota was established as the 32nd state of the Union. This opened new frontiers for immigrants searching for land. William and Alexander Kinkead worked as surveyors for the government road stretching across the state to the western border along the Red River Trail route. Their work brought them to the shores of Lake Agnes, to a beautiful wooded place surrounded by crystal clear lakes, where they staked a claim and established the townsite of Alexandria.

Four families and a number of unmarried young men wintered at the site. As more settlers arrived, the village soon grew to over 50 families, including that of the Kinkeads' older brother George. By 1862, many of the men left to fight for the Union in the Civil War. That same year, the growing tensions of the United States' war with the Dakota Indians caused nearly all of the remaining families to flee to St. Cloud, located about 60 miles east of Alexandria. The conflict lasted only six months. Within a short time, Civil War soldiers arrived to build Fort Alexandria, a stockade that created a safe place for the townspeople. Very few early settlers returned; they included James Van Dyke, Thomas Cowing, S.C. Cowing, and the Blackwell and Canfield families.

The end of the Civil War ushered in a period of rapid growth for Alexandria. Returning veterans were entitled to 160 acres of free land and came to seek out business and professional opportunities. The village grew steadily, and Alexandria was once again a thriving community.

In 1866, William Everett Hicks, a financier and entrepreneur from New York on a hunting and fishing trip, found the area to be good for his ailing health. In 1867, he purchased the townsite. His contributions to the civic, commercial, and industrial life of the growing community gave Alexandria a second beginning.

Alexandria was officially set apart, constituted, and incorporated as a village with a population of 800 residents in 1877.

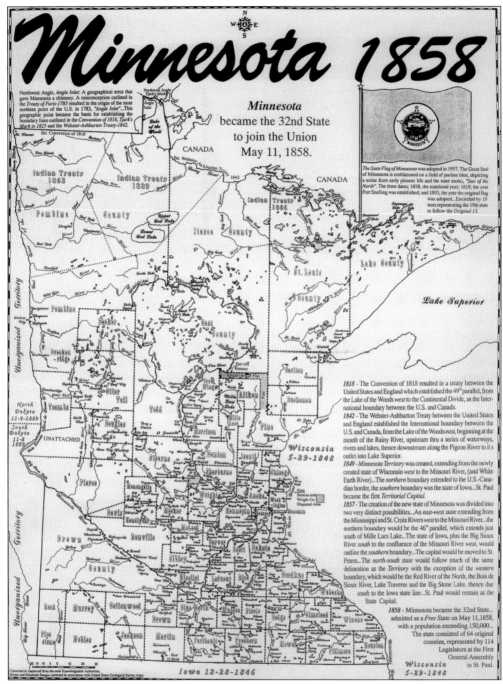

THE STATE OF MINNESOTA. In 1858, Minnesota became the 32nd state of the Union. This land of wilderness, woods, prairies, and lakes was home to both the Sioux and Chippewa Indian tribes. The Red River Trail that crisscrossed the land was the main route for oxcarts and wagon trains passing through the state to the western border. Settlements were established in the area that was later named Douglas County.

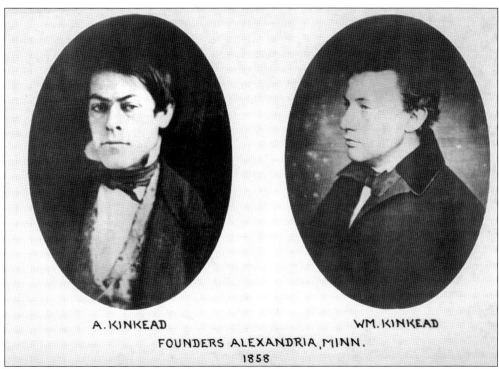

A. KINKEAD WM. KINKEAD
FOUNDERS ALEXANDRIA, MINN.
1858

FOUNDERS OF ALEXANDRIA. A noteworthy event of 1858 was the surveying of the government road from St. Cloud to the western border of Minnesota. William and Alexander Kinkead worked as surveyors in west-central Minnesota, looking for land for their brother George. Charmed by the beauty of the lakes, they acquired land, built a cabin on the shore of Lake Agnes, and named the site Alexandria. They are credited with the founding of Alexandria.

ALEXANDRIA REGION MAP, 1860. George Kinkead joined his brothers, built a log home, and sent for his family. Kinkead drew this 1860 map of the Alexandria region of Minnesota to send to his wife's relatives in New Castle, Delaware. Several of the surrounding lakes were given Kinkead family names.

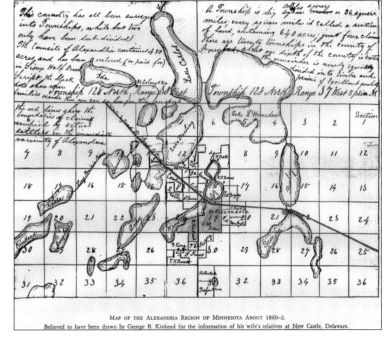

MAP OF THE ALEXANDRIA REGION OF MINNESOTA ABOUT 1860-2.
Believed to have been drawn by George B. Kinkead for the information of his wife's relatives at New Castle, Delaware.

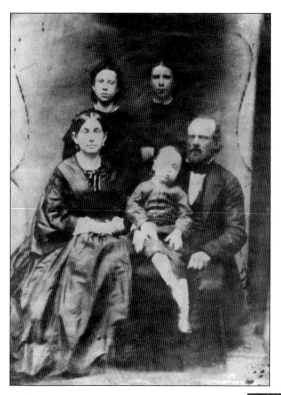

George Kinkead Family. George and Clara Janvier Kinkead are pictured here with their children Ginny (left), Amy, and baby boy Spotswood. They enjoyed life in the wilderness—planting gardens, raising chickens and pigs, and boating and fishing in the lakes surrounding the village. Both George and Clara were respected leaders of the small village.

Clara Janvier Kinkead. Clara recorded details of her travel from Delaware with the children, by train, steamboat, stagecoach, and covered wagon, arriving in the frontier village on July 5, 1860. She portrays the daily routine of the first settlers showing courage and calm leadership during the exodus from Alexandria in 1862. Her original journal, a sensitive account of life in the new settlement, is preserved at the Douglas County Historical Society.

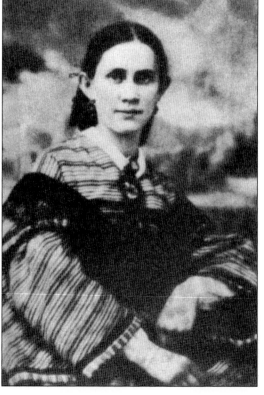

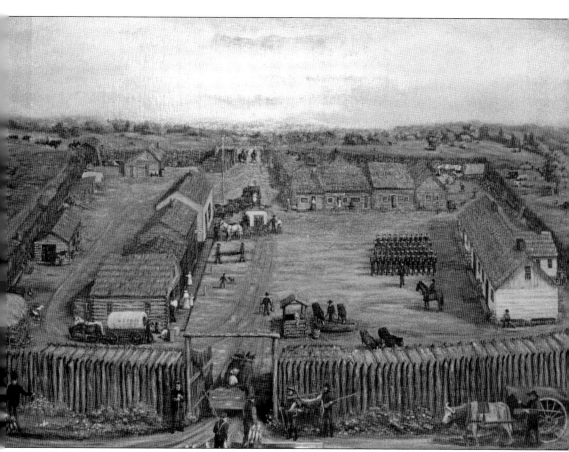

THE CIVIL WAR AND US–DAKOTA WAR, 1862. Two events led to a potential end to the new village: Many young men in Minnesota were recruited to serve in the Civil War, and the US–Dakota War of 1862 caused the settlers in the western part of the state to flee to St. Cloud for safety. After the US–Dakota War ended, many of the early settlers returned; however, none of the Kinkead family members returned to Alexandria. William received an appointment to a government clerkship in Washington, DC, following his service in the Civil War. Alexander went to California in 1868, where he spent the remainder of his life. George died following an injury while building a log home in St. Cloud. Clara returned to her family in Delaware with the children. In 1866, the governor of Minnesota directed Civil War soldiers to build a stockade. Fort Alexandria became the center of business and social life. Among the returning settlers was James Van Dyke. He operated a sutler's store inside the stockade and managed the post office. Thomas Cowing returned to establish a mercantile store and a small hotel. The stockade stood on the hill overlooking Lakes Agnes until it was torn down by order of the city council in 1878. Fort Alexandria is depicted in detail from sketches and blueprints provided to Ada Johnson, a local artist.

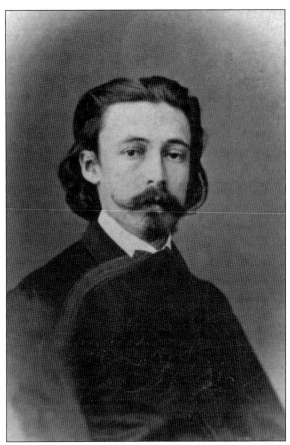

WILLIAM EVERETT HICKS. The end of the Civil War ushered in a period of very rapid growth for the area. Among those who came to Alexandria was William Everett Hicks, a financial editor of the *New York Evening Post*, who came on a hunting and fishing trip and found the climate good for his ailing health. In 1867, he purchased the townsite, which created a revival of Alexandria. He opened a general store, built a gristmill and sawmill, started a newspaper, and provided land for the courthouse, three churches, and a school. Hicks built a small log home on the western shore of Lake Agnes near the original townsite that had been established by the Kinkead brothers.

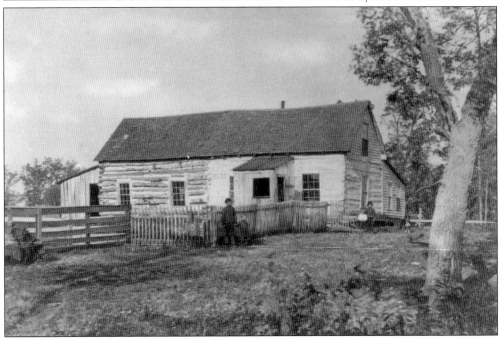

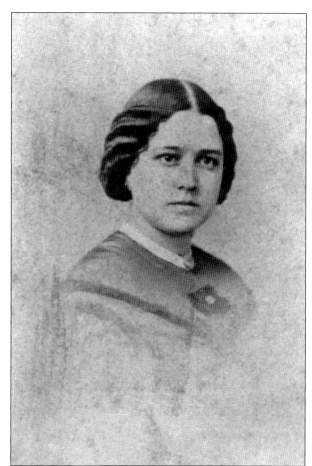

THERESA THOMAS HICKS. Theresa Thomas Hicks continued the extensive plans for Alexandria that had been established by her husband, William Everett Hicks, before his death in 1874. The Hickses' contributions to the civic, commercial, and industrial life of the growing community created a solid foundation for the town. Theresa built a new home on Fillmore Street and Sixth Avenue. She was a shrewd businesswoman who bought up unclaimed homestead land and made a good profit on its resale. She died in 1910 at the age of 82.

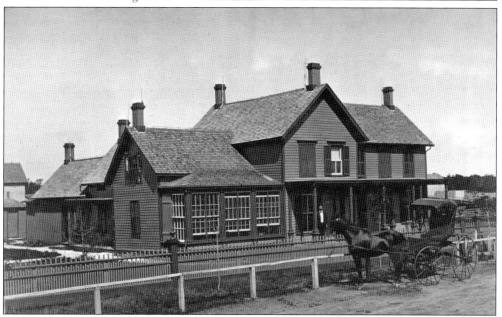

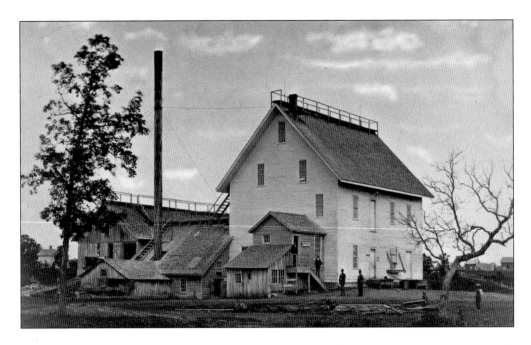

THE HICKS MILL AND LOG STORE. The Hicks Mill was located on Main Street (now Broadway) between Eighth and Ninth Avenues. Hicks solved the problem of a short supply of lumber by purchasing government timberlands. Changing ownership, the sawmill and gristmill stayed in business until 1907, when it was destroyed by fire. Selecting a good location on the west corner of Sixth Avenue and Main Street, Hicks built a log general store in 1866, one of the first businesses in Alexandria. Ownership changed in 1877 when Charles F. Sims and Horatio Jenkins bought the building, incorporating a general store with a drugstore and a barbershop.

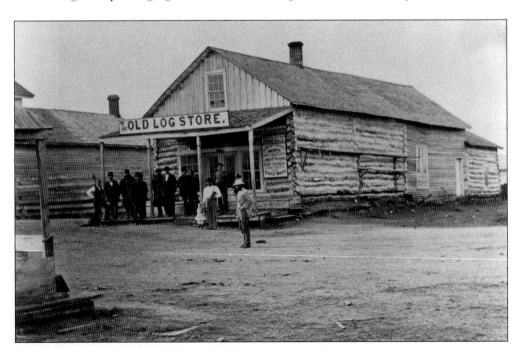

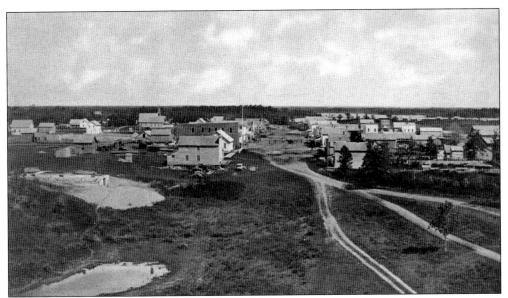

MAIN STREET LOOKING NORTH. This view of Main Street was taken from the Hicks Mill looking north toward Lake Agnes. The business structures erected along Alexandria's Main Street between 1868 and 1876 were enduring monuments to the energy and capital of the entrepreneurs who constructed them.

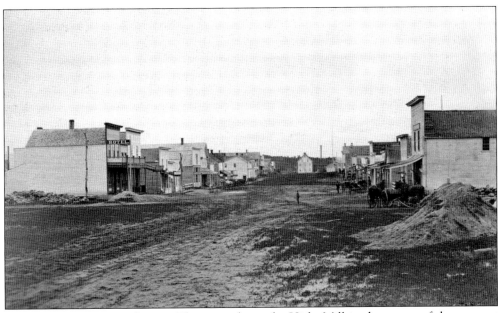

MAIN STREET LOOKING SOUTH. This view shows the Hicks Mill in the center of the street at the south edge of the town. These few blocks were the original heart of the business community in 1876.

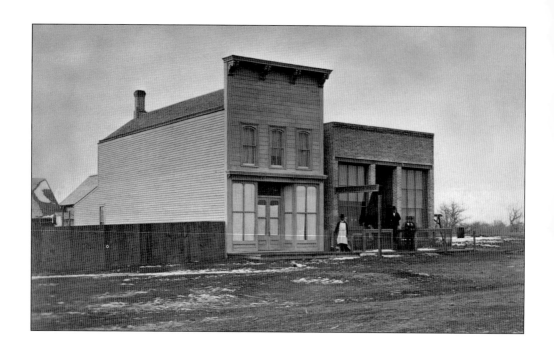

WALK ALONG MAIN STREET. Heading south on the west side of Main Street and Fourth Avenue, the Zimmerman Grocery and the Hoffman Meat Market were among the first business establishments. L.K. Aaker and Company built this general store in 1868 and sold hardware and other merchandise. The sign declares "Grain Bought and Sold." The structure changed hands over the years. The White Swan Saloon was the last tenant before the building burned in 1911.

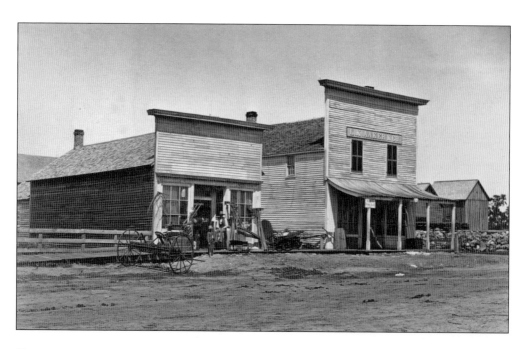

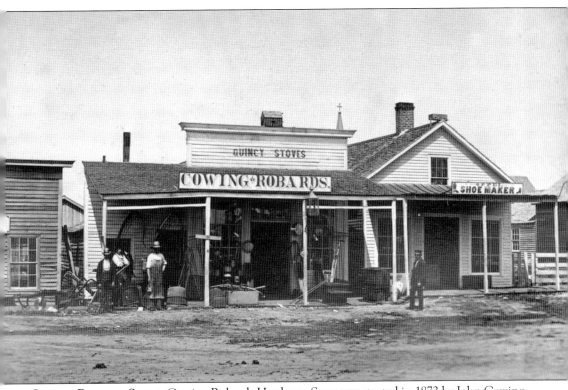

COWING ROBARDS STORE. Cowing Robards Hardware Store was started in 1872 by John Cowing and Oscar Robards. After the death of Oscar in 1918, the ownership was passed on to his son, Pat Robards, who continued to be involved in the management of the store until his death in 1980. The original philosophy, to offer exceptional customer service, is carried on by its present owners, Ed Rooney and his sons Mike and Dan. Ed began working for Pat Robards in 1952 before serving in the military for two years. When he returned, Robards rehired him. The downtown area has undergone many transformations over the years, but one thing remains constant: the site of Cowing Robards store. The 1870 building to the right was Oppel Shoemaker. Owner Christopher Oppel employed five master shoemakers.

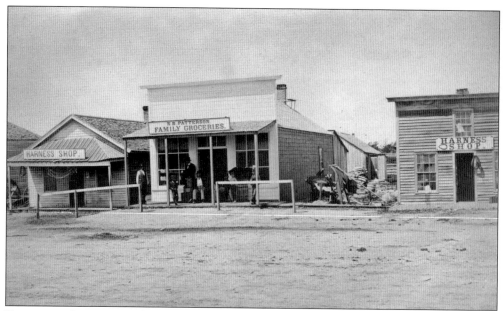

PATTERSON GROCERIES. The grocery store was well stocked with groceries and supplies. The grocery was flanked on each side by harness shops and wooden hitching posts, making shopping more convenient.

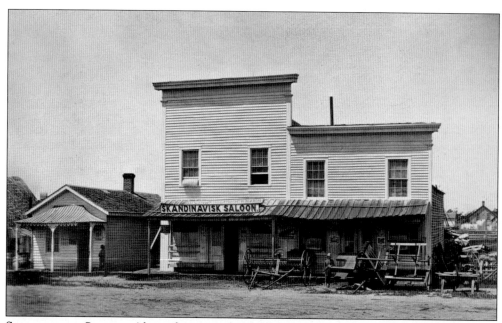

SKANDINAVISK SALOON. Alexandria was a hard-drinking town with 13 saloons and breweries along Main Street. Attorney-at-law N.B. Fulmer had an office above the saloon.

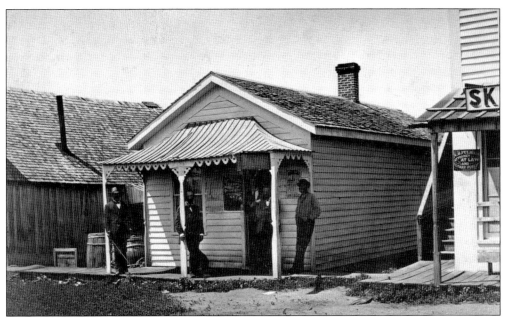

BANK OF ALEXANDRIA. A private bank was founded in 1868 by Frank Van Hoesen, George Ward, and Robert Smith. The three men were actively involved in city government and local society.

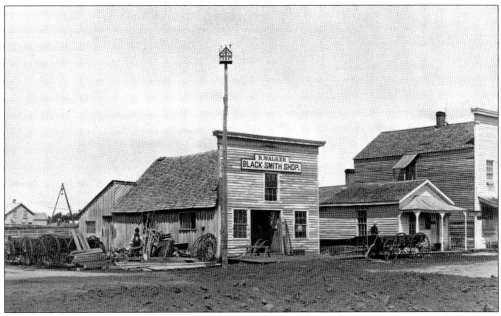

ROBERT WALKER, BLACKSMITH. Walker, a Scottish immigrant blacksmith, convinced Hicks to plan a wide main street because his hometown was completely destroyed when fire jumped from one side of the narrow street to the other. The 76-foot-wide Main Street remains a unique feature of present-day Alexandria.

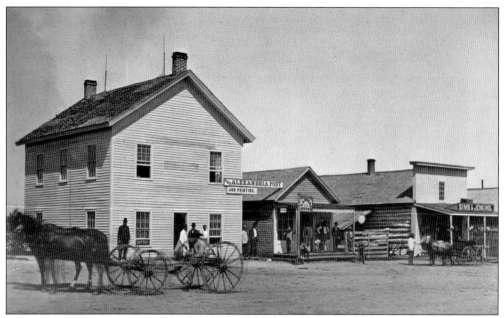

ALEXANDRIA POST BUILDING. The building housing offices for the *Alexandria Post* did double duty as the Douglas County Courthouse and the Hickses' newspaper office. The small building on the right was a combination jewelry store, express office, post office, and office of the clerk of court. The large oaken-face pocket watch drew attention to the advertising on the fence: "Try Deberkman's Bitters."

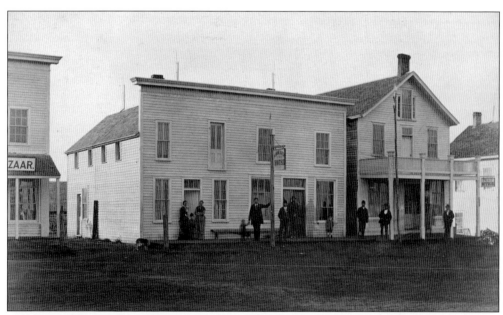

MINNESOTA HOUSE. The oldest hotel in Alexandria was located in the middle of the 600 block on the west side of Main Street, catering to young people who moved to Alexandria with business hopes. The hotel offered temporary housing for people and their horses.

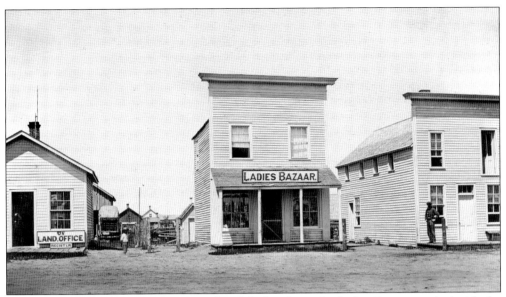

LADIES BAZAAR. The building to the right of the hotel was the Ladies Bazaar, stocked with the latest in ladies' fashions.

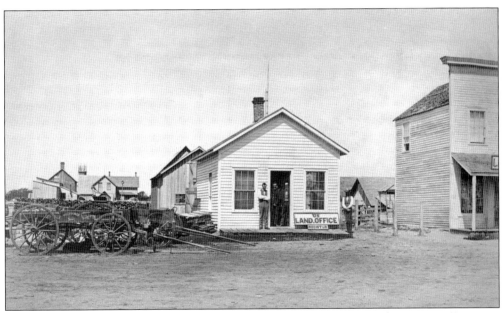

US GENERAL LAND OFFICE. President Lincoln signed the Homestead Act in 1862, giving homesteaders free government land utilizing the General Land Office (GLO). Pictured in the doorway is Knute Nelson, a young attorney. Active in politics, Nelson was elected governor of Minnesota in 1892 and US senator in 1894, where he served until his death in 1923. His home in Alexandria, listed in the National Register of Historic Places in 1976, is headquarters for the Douglas County Historical Society.

H.H. WILSON FARM IMPLEMENT STORE. Essential farm machinery and supplies were available from this store on the west corner of Seventh Avenue and Main Street. The Baker Real Estate office was also housed in the Wilson building. According to the November 10, 1876, *Alexandria Post*, the "Centennial Liberty" flagpole was erected for the United States' centennial celebration.

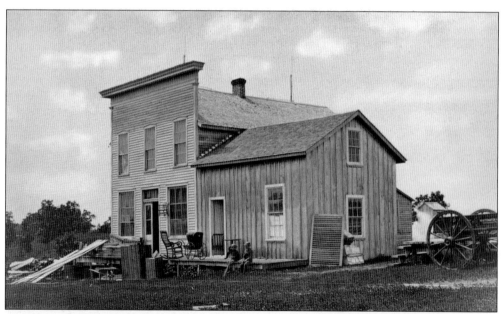

ANDERSON & LUNDGREN FURNITURE. The Anderson & Lundgren Furniture store opened in 1872, producing and selling a good line of cabinets and maple furniture, as well as coffins. The partnership dissolved in 1885, with the Anderson family continuing to operate both the furniture and funeral businesses.

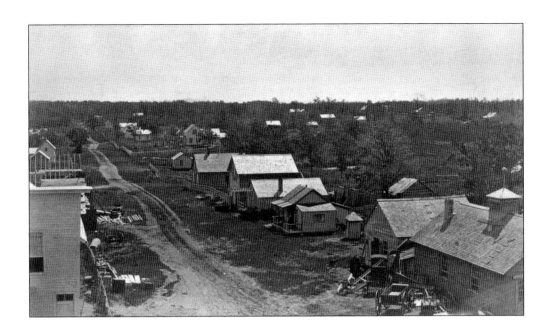

LOOKING EAST. The east side of Alexandria developed with the construction of modest residences for businesspeople, with gardens and flowerbeds behind boarded fences. Backyard space was often shared with horses, pigs, and cattle. Gatchell Fleming, Blacksmith was located on the east corner of Seventh Avenue and Main Street. The chief work of this shop—"the best shoeing in Alexandria"—is shoeing horses and oxen.

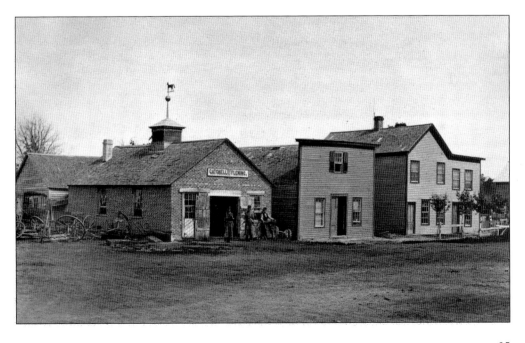

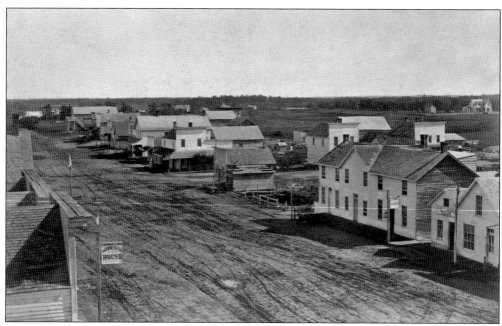

EAST SIDE OF MAIN STREET. The signs for both of the town hotels—the Minnesota House and the Douglas Hotel—are visible across the street from each other in the 600 block of Main Street.

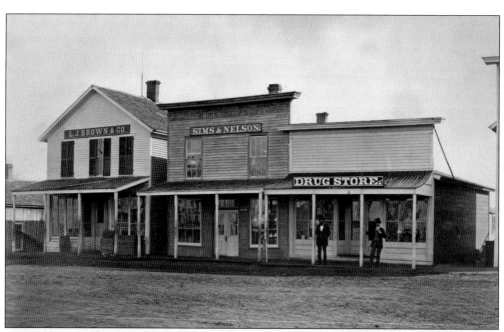

BUSINESSES AND PROFESSIONS. Dr. Lewis J. Brown and Dr. Vivian Godfrey had their office above the Sims and Nelson Drug Store. An active manager of the partnership, Brown married Marie Hicks, daughter of William and Theresa. They remained in Alexandria throughout their lives. In 1876, Lewis J. Brown opened the mercantile store, one of the first of his many business ventures on Main Street. In 1883, he built a larger brick building across the street that featured the first plate-glass windows in Alexandria.

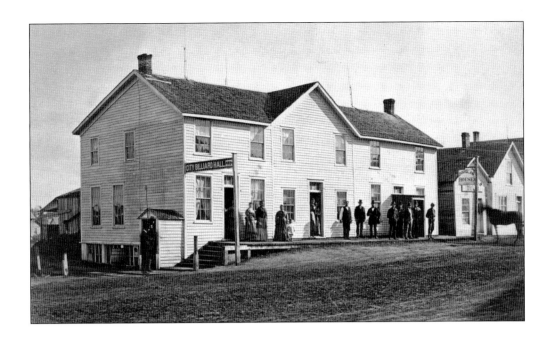

THE DOUGLAS HOTEL. The Douglas Hotel was the stopping place for the Burbank Minnesota Stage Company. The proprietor was the portly and popular Col. Hiram Shippey. A billiard hall was located on the north side of the building. The stagecoach ran routes that originated in St. Paul to St. Cloud, then traveled to points west along the Red River Trail, delivering passengers and goods.

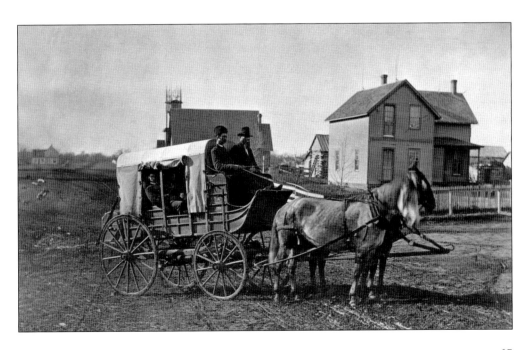

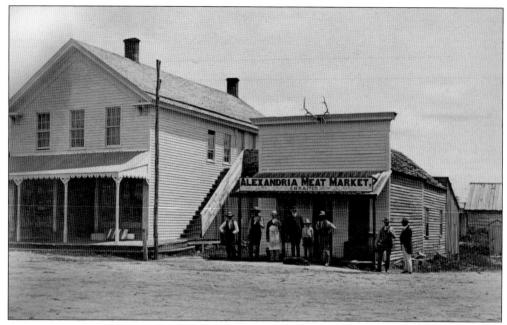

ALEXANDRIA MEAT MARKET. In 1869, Fred Raiter purchased the meat market from John Cowing. Elk and venison were sold in season, as indicated by the elk antlers on the front of the building. Notice the small outhouse to the left of the building.

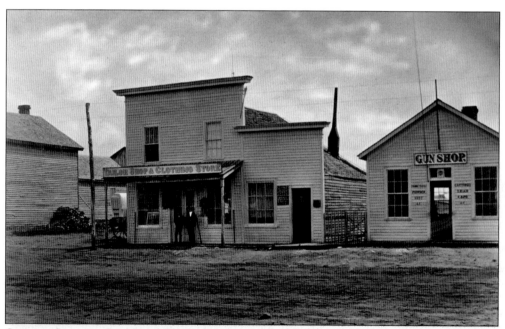

CHARLES SCHULTZ GUN SHOP. The large wooden gun quickly identifies the purpose of this shop. Guns and fishing gear were sold and repaired here. The adjoining building is the Charles Sonday Tailor Shop & Clothing Store.

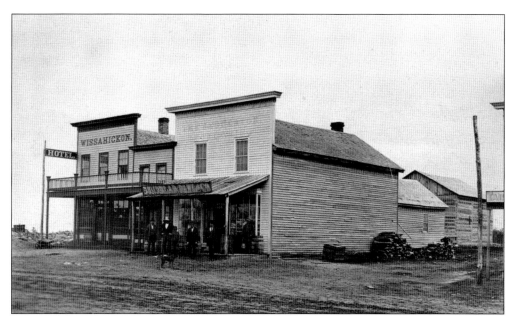

WISSAHICKON HOTEL. This hotel was built by John Donner in 1872 to replace an earlier hotel that burned down. The rough poles support telegraph wires. This structure on the corner of Main Street and Fifth Avenue has changed ownership and purpose many times over the years.

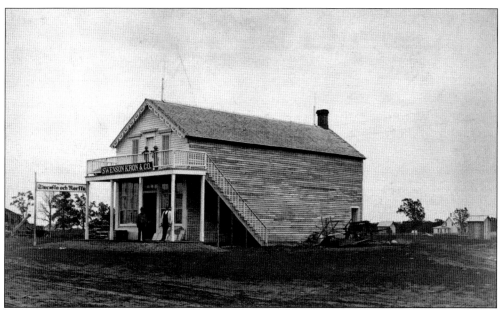

SWENSON, KRON & COMPANY MERCANTILE. Owner John Kron was a member of the first municipal corporation to call for election of the first city council members. This 1876 general store on Fourth Avenue became the site of the Anderson Furniture Store in 1903. John Anderson single-handedly operated the furniture store from 1903 until joined by son Carl in 1910. Grandson Paul joined the owners in 1938. Great-grandsons Tom and David operated the furniture store from 1980 until it was sold to Hennen's Furniture in 1989. The four generations of Andersons was one of the longest-running ownerships in Alexandria.

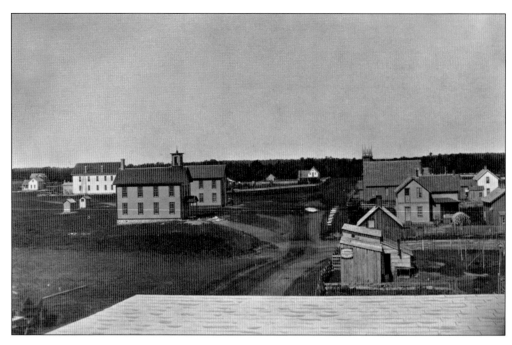

WEST SIDE DEVELOPMENT. The village developed quickly, as evidenced by these 1879 views of the Twin Schools on the left, the Congregational church across the street, and the new courthouse in the background. Hicks donated the land for all of these structures. Alexandria is a city of churches with strong social and philanthropic outreach. A cluster of buildings includes private homes, gardens, and the Methodist and Episcopal churches. The original fairgrounds were located on the south shore of Lake Winona, which can be seen on the horizon. Alexandria Manufacturing Company was built at that location in 1884. Owner L.J. Brown made furniture that was used in several local establishments, including the furnishing for the Dougas County Courthouse.

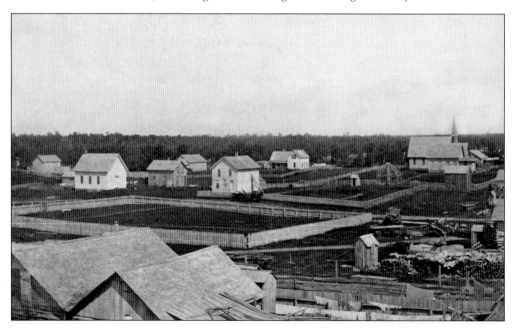

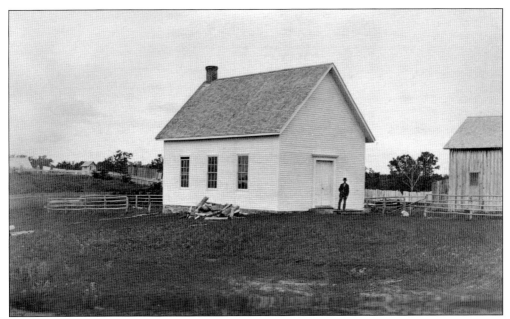

METHODIST CHURCH. The Methodist church was erected on the corner of Sixth Avenue and Fillmore Street in 1867. A second church was built in 1888 on the same site, dedicated by Rev. Richard Grose. This served until 1970, when a new church was built on Sixth Avenue East.

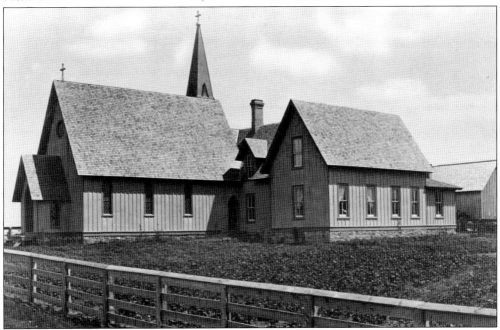

EPISCOPAL CHURCH. Rev. Benjamin Whipple held the first Episcopal services in 1859 in the home of Charles Cook, one of the original citizens of the village. Services were then held in the stockade until 1873. In 1873, the Episcopal church was built following a design by James Tway, based on an old English church, with hardwood, carved beams, and Gothic architecture. The design was unusual, as the steeple is situated at the rear of the building. A new church was built in 1966 on Twelfth Street and Lake Street.

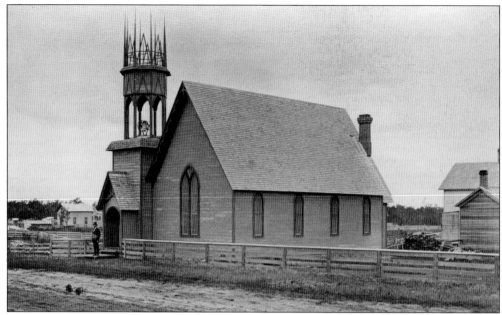

CONGREGATIONAL CHURCH. William and Theresa Hicks donated the land for the first churches in Alexandria—the Methodist, Episcopal, and Congregational. The 1867 Methodist facility was shared for Sunday school classes until the others were built. The original 1875 structure on Seventh Avenue and Elm Street was known as the "Toothpick Church." The steeple was designed by Rev. William Norton to represent the thorny crown of Christ at his crucifixion. When a larger church was built in 1893, the small church was moved and served other congregations until 1976. A third building was constructed following a fire that completely destroyed the church. The pulpit Bible was the only thing salvaged from the fire.

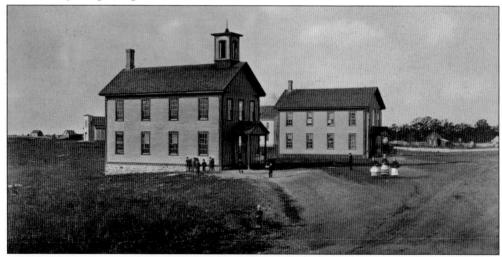

TWIN SCHOOLS. In 1872 and 1876, the Twin Schools were located between Elm and Fillmore Streets. Alexandria Independent School District No. 2 had 379 students registered. In 1883, a new building replaced the twin schools. Both buildings were moved, and one became the Ward School for elementary students, located on Sixth Avenue East. The second building was purchased by Peter Reader for $325, moved to Seventh Avenue and Hawthorne Street, and renovated as a hotel, the Central House.

THE FIRST JAIL AND COURTHOUSE. This 1868 small jail, built with six-foot-thick solid oak walls and one six-inch-by-fourteen-inch window and at a cost of $350, was behind the Main Street courthouse. A new jail was included on the block with the new courthouse in 1879. The first jail structure was sold to local brewer Rud Wegener for $25. Douglas County was permanently organized in 1866. The need for a larger courthouse grew as the population of Douglas County increased. Theresa Hicks agreed to donate the property between Douglas and Elm Streets. The new structure was finished in 1879 and served as the official county courthouse for 20 years. Replaced by the current building in 1900, the old building was moved to a site by Lake Winona and remodeled as a hospital. The 1900 courthouse has had several changes and additions over the years and was listed in the National Register of Historic Places in 1976.

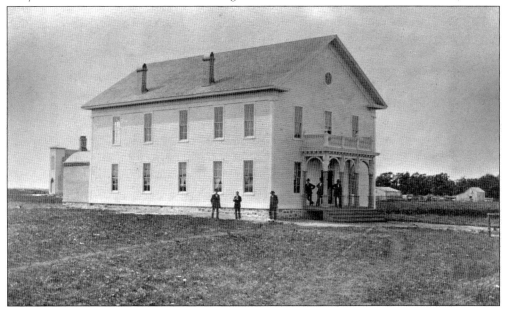

NEWTON J. TRENHAM. Trenham was the official photographer during the formative years of Alexandria. His extensive collection provides a clear picture of each building and the wide variety of trades and professions that shaped the village. The photographs often include the proprietors and customers posing at the entrance to the store. For many years, Trenham remained in business in Alexandria, a town known for its excellent hunting and fishing. This street scene demonstrates the humor of Trenham, showing hunters with guns, fishermen, wooden boats, and duck decoys in the middle of Main Street.

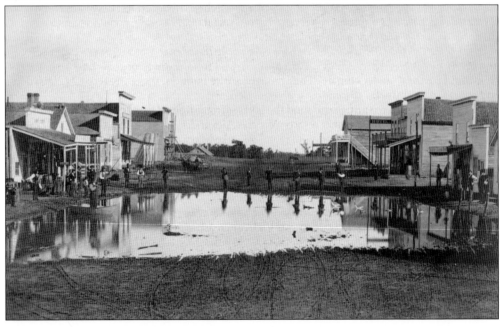

Two

Trails, Trains, and Tourists

The 1876 portrait of Main Street offers historians an opportunity to track the progress of the town. The rough dirt roads were graded and watered to settle the dust. The original wooden storefronts gave way to brick buildings with plate-glass windows. The wooden boardwalks were replaced with cement sidewalks. Sewer systems and electrical wires began to appear along the streets.

The voice of Alexandria was the *Alexandria Post News*, established in 1868 by William Hicks. The editor encouraged and shaped development by documenting the growth of business, buildings, and residences. Civic-minded entrepreneurs often switched the location of business in order to accommodate a new enterprise. The industrial and social quality of the populace contributed to the rapid development of homes, churches, and schools.

With the arrival of the first train on November 5, 1878, Alexandria became part of the main line of the Great Northern Railway. Passengers arrived from warm Southern states to enjoy the bountiful lakes and cooler climate. They brought entire families, including servants, cats, dogs, and trunks of clothing for the entire summer season.

Resort hotels began to spring up around the lakes surrounding Alexandria to accommodate the influx of tourists. The first summer resorts were the Alexandria Hotel on Lake Geneva, Blakes by the Lakes on Lake Carlos, the Maryland Hotel on Lake Mary, and the Minnesouri Club and the Chicago Club on Lake Miltona. The chain of lakes offered bountiful fishing, swimming, boating, and relaxing activities for entire families who arrived from Texas, Oklahoma, and Missouri. The economic impact on Alexandria extended from job opportunities to long-term relationships with the "summer people."

Surrounding farmland could be purchased at a reasonable price. The number of acres under cultivation in Douglas County in 1868 was 4,452, increasing to 26,683 by 1878. The population grew quickly as immigrants arrived from the East Coast, Canada, and Europe, creating a diverse mixture of citizens.

Alexandria was growing up. The following account appears in the local paper from February 25, 1909: "Tonight at 12 o'clock midnight, Alexandria ceases to be a Village and becomes a City, population 3,001."

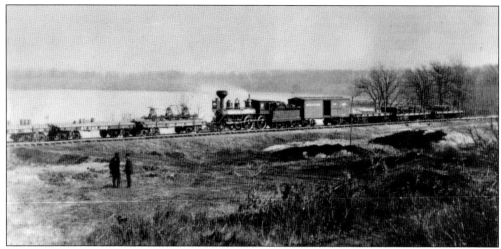

FIRST TRAIN. The long-awaited train arrived in Alexandria on November 5, 1878, an occasion of great rejoicing. Passenger service opened the floodgates for tourists arriving from warm southern states. Once again, the influence of Hicks was evident as he had donated the right-of-way property across the county for the railway. The Northern Pacific declared bankruptcy in 1873. According to Constant Larson's *History of Douglas and Grant Counties, Volume I*, James J. Hill laid the groundwork during the financial crisis of the failure of the banking house of Jay Cook & Company, purchased the property, and reorganized it as the St. Paul, Minneapolis & Manitoba Railway Company. The system gradually built up under the name of the Great Northern Railway, steadily connecting the transcontinental rail line from the East to West Coasts.

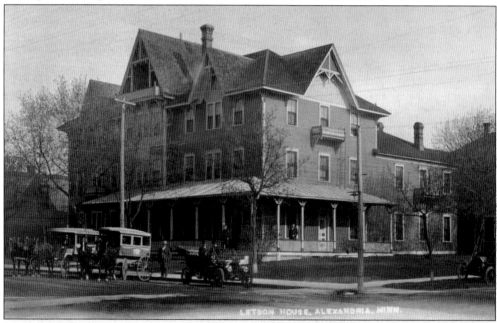

LETSON HOUSE. In 1880, James H. Letson built a resort hotel in Alexandria, the first tourist hotel in Northern Minnesota. Letson had run a summer resort on Lake Minnetonka near Minneapolis, but he could not resist the lure of the bountiful lakes in Alexandria. The Kent horse-drawn bus provided passenger service from the new depot to the hotel. The name of this hotel has changed over the years, but it continues to operate as the Alexson.

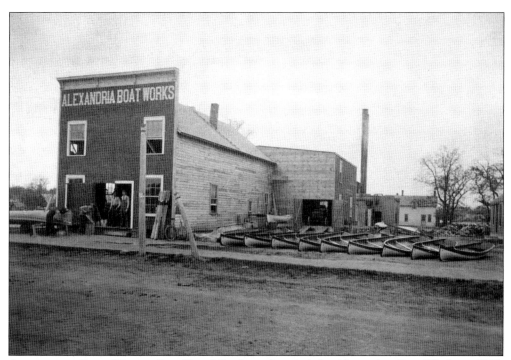

ALEXANDRIA BOAT WORKS. Eric "Boat" Erickson founded the Alexandria Boat Works in 1885, the first boat company in Minnesota and the oldest industry in Alexandria. The first boats were constructed in the traditional wood lapstrake style. In 1902, he designed the smooth convex-concave tapered stay branded as Lady of the Lakes. The company continued operations run by family until 1980. The story of this industry has been preserved by the Minnesota Lakes Maritime Museum, which opened in 2007. Below, one of the Erickson boats is pictured in front of the Alexandria Lumber Company, located on the north end of Main Street.

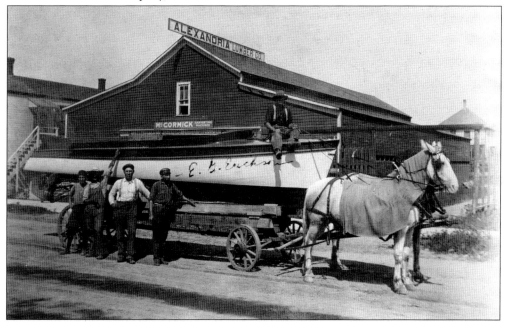

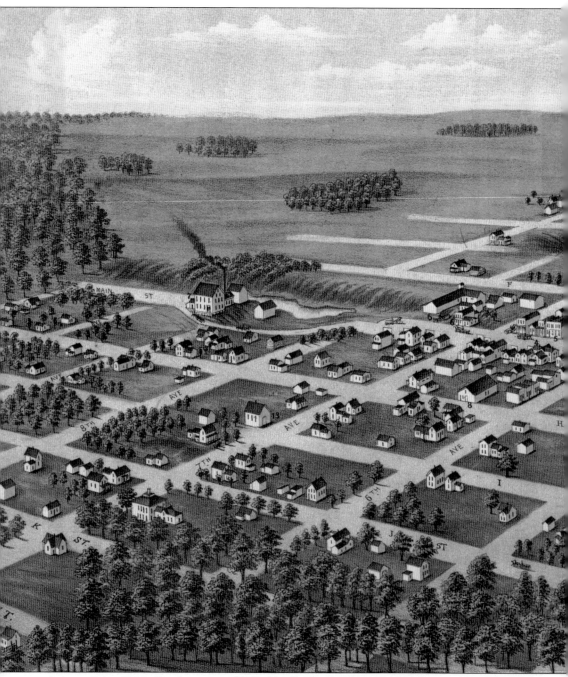

ALEXANDRIA, 1880. On this map published by Fowler & Rhines in 1880, several landmarks are numbered, such as the public schools (1), county courthouse (2) and jail (3), Douglas House (4) and Minnesota House (5), R. Wegener Brewery (6), Alexandria Mills (7), Joseph Colby Livery Stable (8), and five churches—the Episcopal (9), Methodist (10), Congregational (11), Norwegian

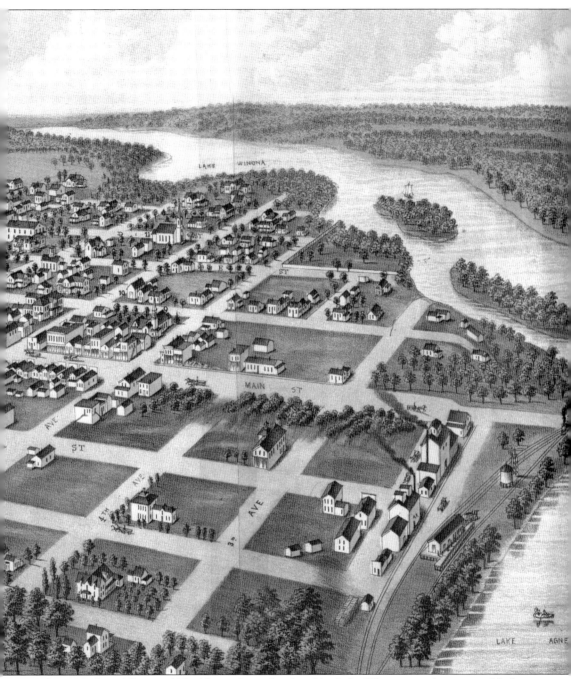
Lutheran (12), and Baptist (13). Alexandria is bordered by Lake Winona on the west and Lake Agnes to the north. The old depot and warehouses of the Great Northern Railway were located on the north end of the village.

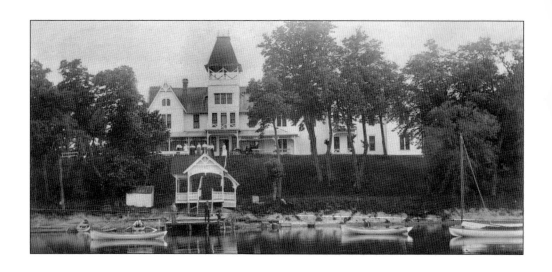

GENEVA BEACH HOTEL. J.H. Letson continued to promote tourism by adding another resort hotel on the south shore of Lake Geneva, a good fishing lake on the east side of town. The Alexandria Hotel opened in 1883, taking advantage of the Great Northern Railway line, which lay 500 feet from the entrance to the new hotel. In 1896, J.L. Dickinson acquired the resort and changed the name to the Geneva Beach Hotel. A fire caused by "those infernal new electric lights" destroyed this fine building in 1911, according to the 1978 book *And Then Came Summer*, by Jane Delay and Peg Schoellkopf. In 1917, Harry L. Dickinson, son of J.L. Dickinson, rebuilt the hotel, calling it the Dickinson Inn. The name was returned to Geneva Beach Resort, and it is currently in operation at the same location as the first hotel. A gazebo served as the waiting station for the arrival of the train carrying eager passengers. The fishing was good, the accommodations were great, and the tourists were happy.

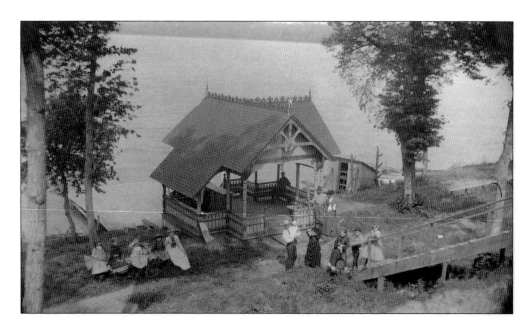

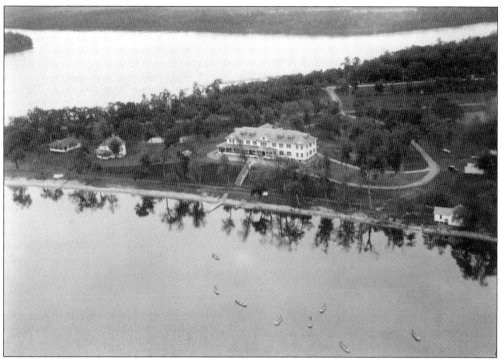

LAKES VICTORIA AND GENEVA. This aerial view shows Lakes Victoria (upper left) and Geneva (lower right) on either side of the Dickinson Inn, which replaced the burned Geneva Beach Hotel.

THREE HAVENS BRIDGE. A dirt road heading north from Alexandria crosses the junction of Lakes Carlos and Le Homme Dieu. Improvements to the road were made as traffic increased. This was and still is a popular spot for swimmers, offering a shallow, sandy shoreline.

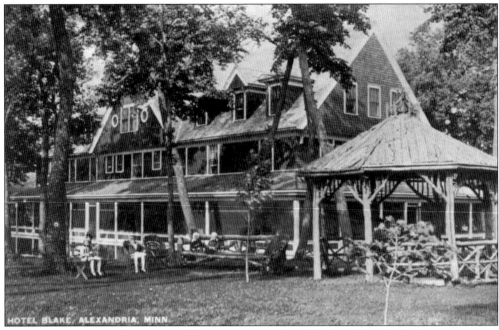

BLAKES BY THE LAKES HOTEL. In 1903, another resort hotel built by John C. Blake and his wife, Eliza Jane, opened near Three Havens, situated at the junction of three lakes—Carlos, Darling, and Le Homme Dieu. Early quarters for the help were segregated, with white chauffeurs sleeping in the attic and black employees in the garage. The hotel flourished and served tourists until 1920, when fire destroyed most of the building. In 1923, new owner Arthur DuBeau opened the rebuilt hotel to serve tourists arriving by train or car from Texas, Oklahoma, Iowa, Kansas, and Missouri. Rates were $10 a day for the American plan, which included meals. The new building included this elegant dining room. An unusual feature of the dining room was a live tree in the center of the room. Many graduation celebrations were held here, and local young men and women served as housekeepers and kitchen staff, making $30 a month plus room and board.

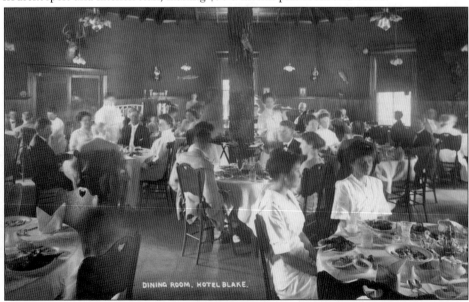

A Day's Catch of Fish at Blakes. Novice fishing guides were paid $2.50 per week; expert guides, $3.00 a day.

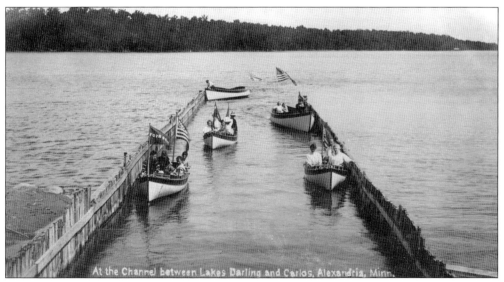

Carlos and Darling Channel. In 1907, several Alexandria Boat Works Lady of the Lakes boats are pictured moving through the channel between Lakes Carlos and Darling. The channel connection allowed boat traffic into the Chain of Lakes.

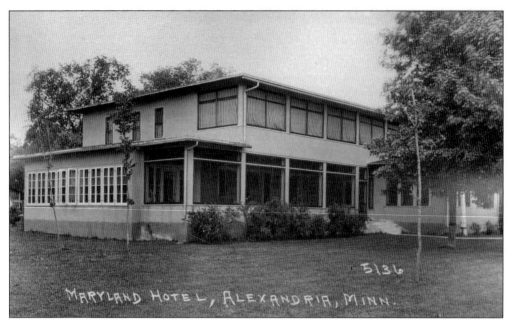

MARYLAND HOTEL. This resort hotel was built on Lake Mary by Fuzzy Reynolds, a popular fishing guide. There were two dining rooms for guests: the main dining room and a private party room.

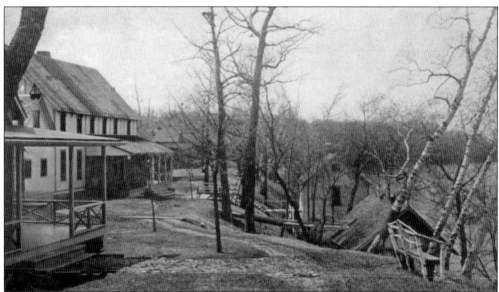

MINNESOURI ANGLING CLUB. The Minnesouri Angling Club was founded in 1890 by a group of men from Minnesota and Missouri, combining the names to form "Minnesouri." The clubhouse for members on the bluff overlooking Lake Miltona included a large dining room. Nineteen families built private cottages that have been passed on to the fourth and fifth generations, who return to spend their summer vacations there.

CHICAGO CLUB. Lake Miltona is one of the largest lakes in Douglas County. The Chicago Club and Manmouth Club were popular resorts offering good fishing, boating, and easy living for tourists.

CHAMBER OF COMMERCE. The chamber of commerce originated in 1907 as the Businessmen Association, then changed its title to Alexandria Commercial Club until February 23, 1928, when a new headquarters opened on Main Street, permanently called the Alexandria Chamber of Commerce. Their purpose remains the same: to promote the village of Alexandria as a tourist destination.

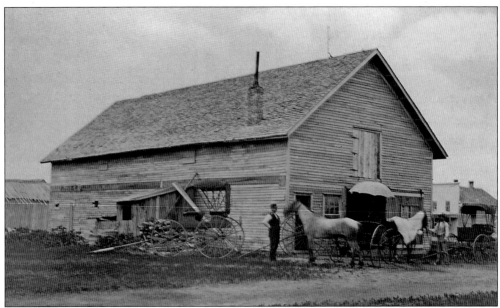

LIVERY STABLE. Horse-drawn carriages and buggies were the mode of transportation, with several livery stables, blacksmith shops, and harness stores in the business section.

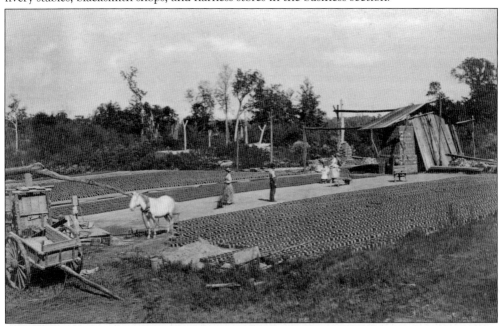

BRICK MANUFACTURING COMPANY. John A. McKay owned and operated the Alexandria Brick Manufacturing Company for 26 years. Using horsepower for mixing clay for bricks and forms for drying bricks in the sun, the company had the capacity to make a million bricks a year. Starting in 1870, he employed 12 to 16 workers during the rapid building boom of Main Street, making most of the bricks used in and around Alexandria. He also served as a justice of the peace, sold real estate, and opened a grocery store with his sons. McKay was recognized as one of the most tireless workers who would benefit the town. His family home stands on McKay Avenue and Sixth Street.

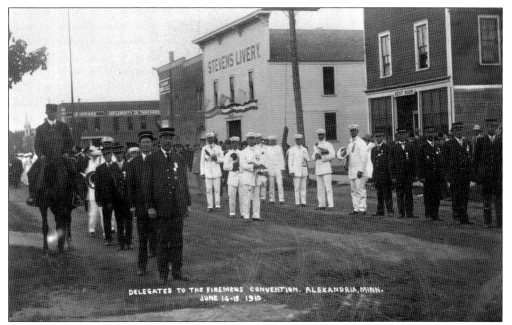

ALEXANDRIA FIRE DEPARTMENT. The city council requested the purchase of the necessary outfit to properly equip a hook and ladder company on March 15, 1880. The council adopted Ordinance No. 22 to establish a volunteer fire department in 1883. Two chemical engines were purchased and stored at Seventh Avenue and Fillmore Street. Incorporated in 1905, the department has hosted the state firemen's annual convention about every 10 years or so since 1910.

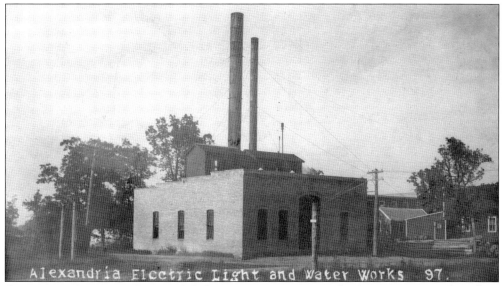

ALEXANDRIA LIGHT AND POWER. A *Lake Region Press* notice reads, "January 29, 1889 the village of Alexandria Ordinance No. 41 be adopted granting the right for the establishment of an electrical plant and providing for power for the operation of water works." At a cost of $8,500, J.S. Hardenbeck established an electric light plant, which he sold to the city. A steamboat whistle was installed to toot the correct time and announce fires. Alexandria Light and Power (ALP) continued to increase service to 9,300 customers in 2012.

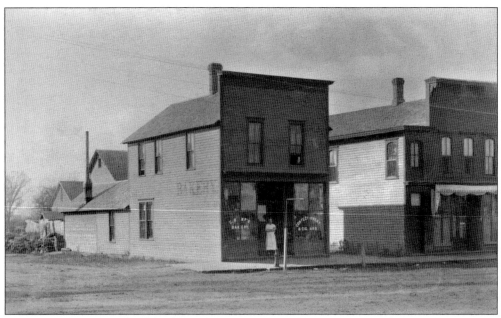

ST. PAUL BAKERY. New brick buildings began to replace the wood-framed shops. In 1889, the St. Paul Bakery opened with owner Carl Hamp. Located on the corner of Fifth Avenue and Main Street, the bakery featured a large brick oven capable of baking 250 loaves of bread at a time. Ownership changed in the ensuing years, but the location and purpose remain the same; it is now operated as the family-owned Roers Family Bakery.

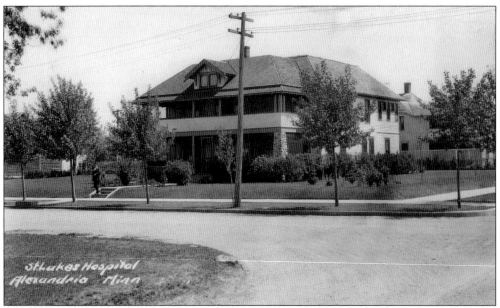

ST. LUKES HOSPITAL. Dr. H.A. Boyd opened St. Luke's Hospital in 1883, with Erica Bach in charge of the six-bed facility. She was a nurse who also took care of the laundry, cooking, and housekeeping. She managed the hospital for 46 years. The cost of care was $12 per month.

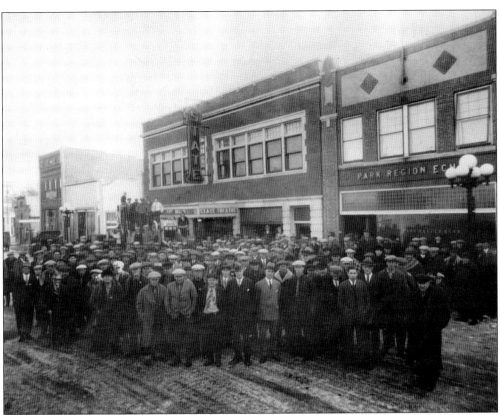

NEWSPAPERS. The first local newspaper, the *Alexandria Post*, was published by William Everett Hicks in 1868. In 1871, it was sold to Joseph Gilpin, who published until 1874, when A.B. Donaldson took over and renamed it the *Douglas County News*. It was then consolidated as the *Post News* until 1902. Carl Wold moved the *Echo* paper from Brandon, where it had been called the *Brandon Bluebell*. The *Echo Press* is now the official newspaper of Douglas County, published twice weekly.

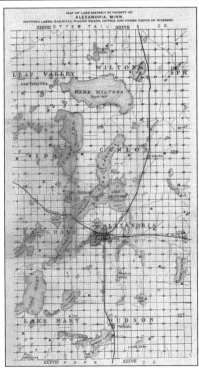

SOO LINE RAILROAD. A Soo Line promotional brochure includes this map of the lakes surrounding Alexandria and shows two railroads—the Great Northern and the Minneapolis, St. Paul & Sault Ste. Marie (or the Soo Line). The Soo Depot opened September 3, 1903, on Sixth Avenue East. Passenger service remained until 1967. The depot was demolished in 1979, but grain and machinery are still transported daily on the Soo Line.

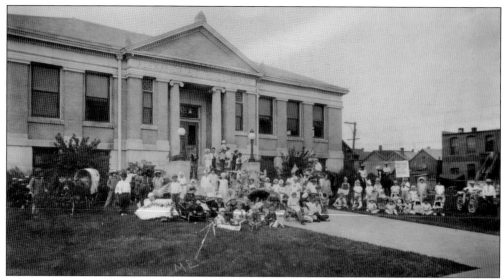

CARNEGIE LIBRARY. A small circulating library was established by a reading club in 1878. A donation of $12,000 was secured from Andrew Carnegie for the erection of a free public library in Alexandria. The city gave land on the same block as the Letson House. The Carnegie library opened on October 14, 1904. The city turned the library over to the county in 1991, and the Carnegie building was sold to a private party. Douglas County opened a new library in 1995 at 720 Fillmore Street, the old Central School site. The Carnegie building is listed in the National Register of Historic Places.

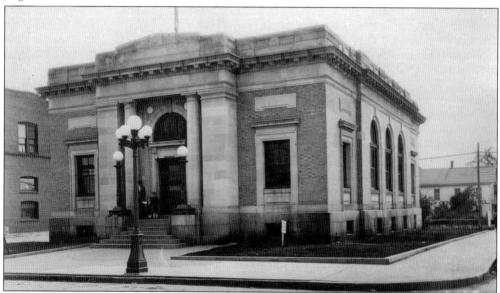

US POST OFFICE. The first post office was established in 1858. Charles Cook was in charge of the mail carried between St. Cloud and Fort Abercrombie, and Alexander Kinkead also distributed the mail from his cabin. Several other men were appointed to the post from 1866 until 1888, when Fannie Van Dyke, daughter of Charles Cook, succeeded her husband following his death. In 1908, funds were appropriated for the handsome US post office, which opened on February 22, 1911, serving until 1977 when a new post office opened on Sixth Avenue and Fillmore Street. The old building is listed in the National Register of Historic Places.

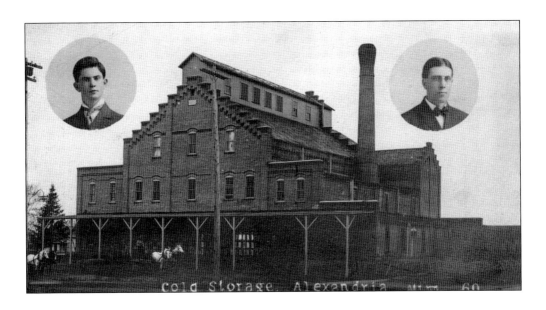

NORTH AMERICAN CREAMERY. Opened in 1906 by Frank Noonan at a cost of $50,000, the cold storage plant picked up farm products with a fleet of trucks and processed chickens, eggs, and turkeys to be shipped by train. Following World War I, the creamery brought in a whole bucket brigade of blue-collar workers—despite the attitudes of the white-collar townspeople who only wanted a tourist town. Located on Sixth Avenue East adjacent to the Soo Line tracks, the creamery had ideal access to shipping. The Noonan home in the foreground includes a view looking west toward downtown Alexandria. The water tower (upper left), school and courthouse (left of Sixth Avenue at upper horizon), Washington School (upper right of Sixth Avenue), and St. Mary's Church steeple (upper right) can be identified in the background. Sixth Avenue, periodically called Lincoln Avenue, was on the main route for travelers arriving from the East on the old Red River Trail, now a state highway.

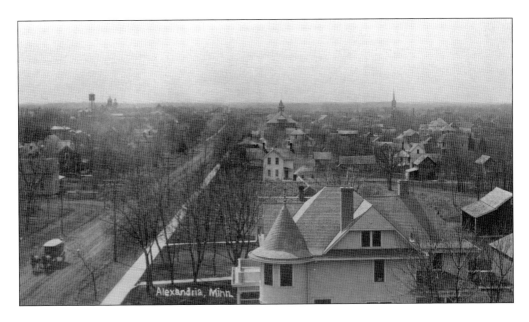

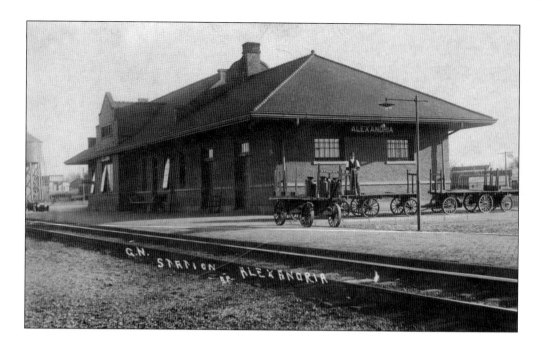

GREAT NORTHERN DEPOT. Built in 1907 of red pressed brick with a slate roof, tile floors, and stone sills at a cost of $25,000, the depot continued passenger service until 1967 and freight service until 1976. The depot was listed in the National Register of Historic Places in 1976. The building was purchased in 1984 and converted into a restaurant called the Depot Express. Sen. Knute Nelson always traveled from Washington, DC, to his home in Alexandria. In this 1915 image, he is welcomed at the depot with fanfare and celebration.

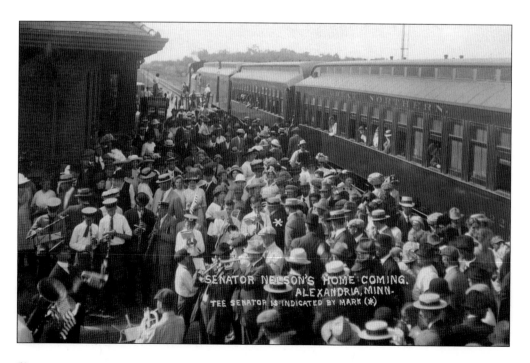

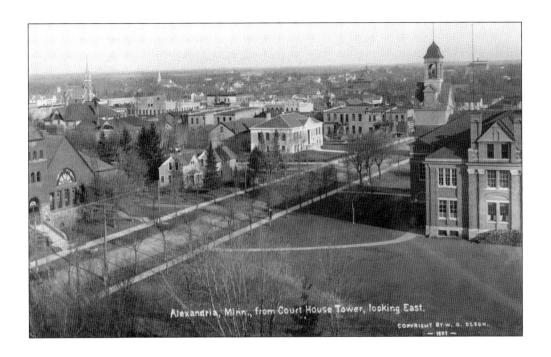

VIEWS FROM THE COURTHOUSE. Two views looking north from the courthouse provide a bird's-eye view of Lincoln High School, Congregational and Methodist churches, Carnegie library, Letson House, and buildings and homes extending outward to Lakes Agnes and Winona.

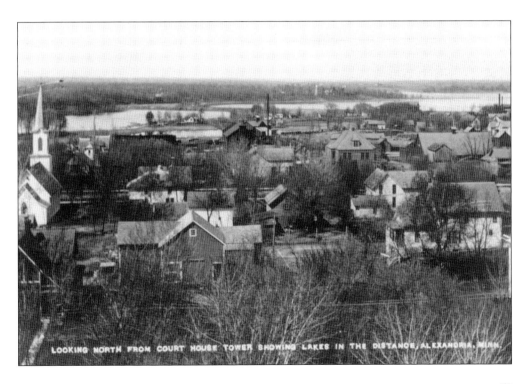

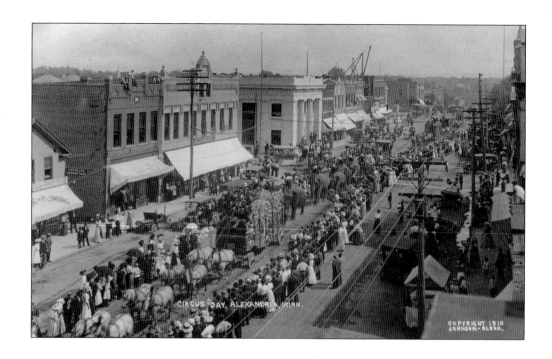

ALEXANDRIA THE CITY. The tradition of parades on Main Street started in 1902. This July 4, 1909, parade was held in celebration of the village of Alexandria achieving official designation as a city. Power lines, telephone wires, and a crane for construction of the new US post office are seen. Buildings on the east (above) and west (below) sides of the street have changed from wood to brick.

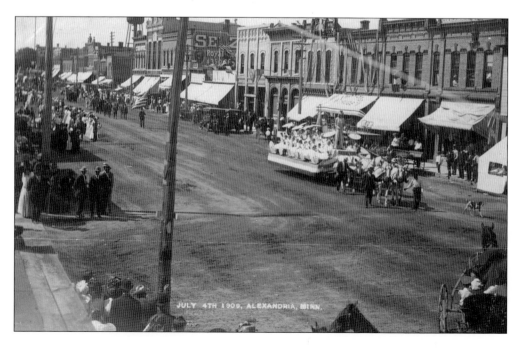

Three

GROWING UP

When Alexandria became a city, it began to grow rapidly. The basic structure was established. The governance of the city and county was settled. Amenities of culture, schools, and churches expanded, and the library and post office joined the ranks of new buildings in the heart of town. Additional businesses on Main Street continued to fill the needs of the growing population. ALP worked with the city council to add utilities and sidewalks and pave the main business section as sewer systems were completed.

Until 1913, the standards for roads and bridges was under the control of the county. City surveyor John Abercrombie was charged with the task of setting the grade for improvement of city streets. Tourist traffic increased with the continued upgrade of Minnesota State Highways 29 and 27, the main routes into town. Two railroad companies—the Soo Line and Great Northern—connected Alexandria to all points of the compass.

The Silk Stocking District includes some of the finest examples of residential architecture from 1865 to 1930. The homes are significant for their association with a collection of men and women who laid the foundation of the business community and contributed significantly to the establishment of public and cultural affairs. Sixty-one properties on Douglas and Cedar Streets were listed in the National Register of Historic Places in 2001.

Alexandria began to spread its wings. In 1922, the name of Main Street was changed to Broadway. The "ABC" street designation became Ash, Bryant, Cedar, and so on, and city postal delivery began in 1924.

Amidst the Great Depression, one person stepped up to create jobs for unemployed town people. Phil Noonan, owner of North American Creamery, created projects that enhanced the city. He purchased land for two city parks, created a tourist garden, funded a baseball park and the airport, started a bowling alley, and planned and built 29 model homes for his employees—one of the first housing developments in the state. World War II ended on August 15, 1945.

The rapidly expanding city made a number of changes in local businesses during 1948 and 1949. Victoria Heights and Westwood additions supplied 80 new housing lots to the city. Nineteen new business firms opened, and 250 new sewer connections were made. ALP received a million-dollar loan for new mercury vapor lighting and water extensions. Alexandria had grown up.

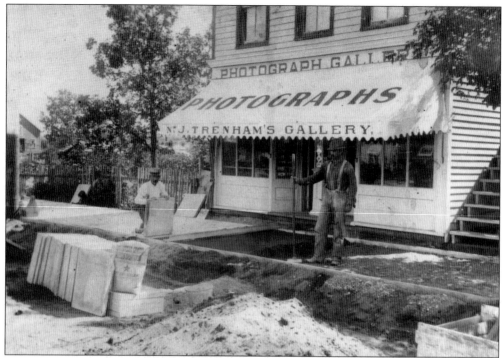

CITY IMPROVEMENTS. Sidewalks replaced the old wooden boardwalks along Main Street in 1913. Electric power, three globe streetlights, sewer lines, and water pipes enhanced the business section of the city.

DUSTY STREETS. Rube Morse uses a horse-drawn water tank to keep the dust down in this 1919 image of Main Street. Gone is the corner building on Sixth Avenue, the 1876 Douglas Hotel, replaced by Farmers National Bank in 1908.

VOLK BREWERY. One of the earliest brick buildings in Alexandria was the three-story Volk Brewery, built in 1912 and located on the west side of Main Street, with caves under the building for storing beer. The caves were unearthed in 1954 when the building was demolished to make Fourth Avenue a through street.

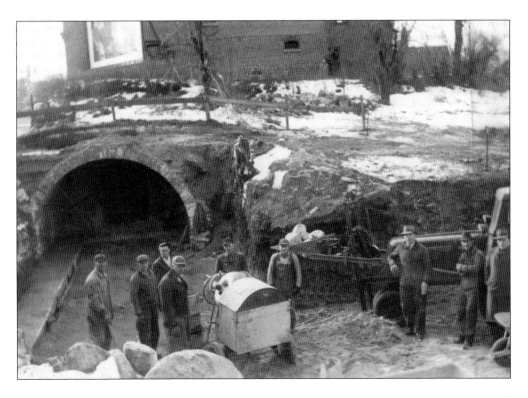

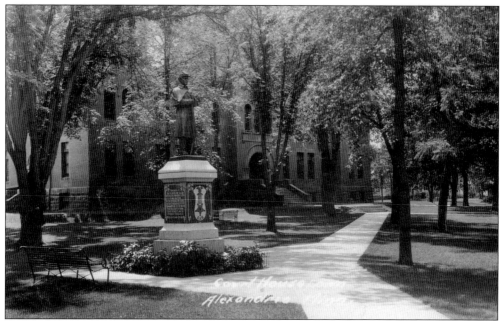

CIVIL WAR MONUMENT. A life-sized bronze soldier stands guard on the courthouse grounds. The plaque reads, "In memory of Soldiers and Sailors of the Civil War 1861—1865," with the emblem of the Grand Army of the Republic at the base of the monument. It was dedicated on May 30, 1916. About 675 men from Douglas County served in the war.

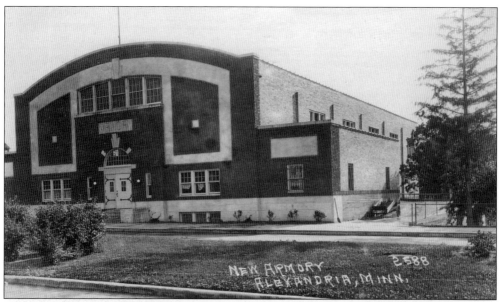

THE ARMORY. Minnesota National Guard Company L 6th was formally mustered, with noncommissioned officers receiving appointments. The new armory was dedicated in 1922 by Gov. J.A. Preus. The Honorable Knute Nelson was one of eight remaining Alexandria veterans of the Civil War who attended the dedication. The armory has continued to serve the military through peacetime and ensuing wars.

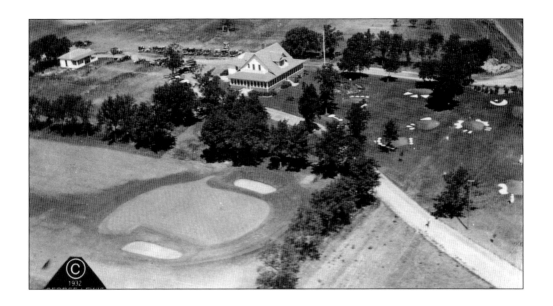

ALEXANDRIA GOLF CLUB. The Alexandria Golf Club opened in 1915. The 18-hole course is located on the southeast shore of Lake Darling. The seventh green is laid out in the shape of the state of Minnesota. The clubhouse is a center for social activity for residents and summer tourists. The Resorters Invitational Golf Tournament has been held annually since 1921 during the first week of August. An active junior golf program gives many young people a shot at fame and fortune and proudly claims as a past participant Tom Lehman, currently a champion on the senior tour.

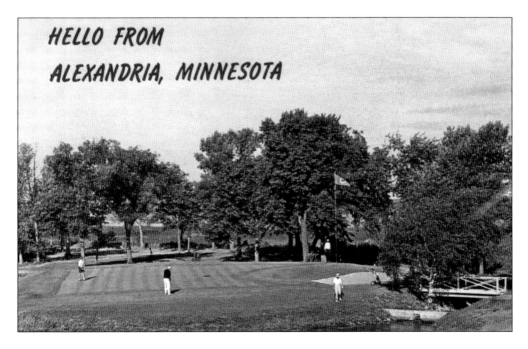

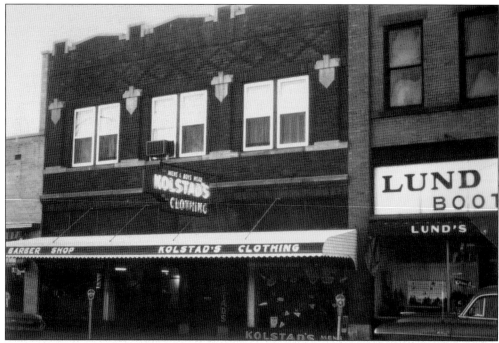

MEN'S CLOTHING STORES. Two businessmen and civic leaders exemplify this quote by Erc Aga, a local radio personality: "Our town is not what it is because of the lakes, wide streets and nice homes. It is because of the people who live here." The Eagle Clothing Company opened in 1911 with Cleve "Spot Cash" Kolstad opening his "Fine Line Of Men's Clothing." Karl "Bud" Kolstad joined his father in 1930, and he was later joined by his son Kurt. Kolstad's Clothing closed in 1995 after 85 years of family ownership. Bob's Clothing was established in 1927 by Bob Chan, who had worked for Kolstad's Clothing before going into business for himself. His twin sons joined him in the business, which operated until 1991. Their logo, "Bob and the Twins Want To See You," won awards for advertising. Located in the former First National Bank building, the store was decorated with antiques. Kolstad and Chan both remained active in leadership roles in Alexandria while competing with each other, always working together for the good of their town. Bob Chan died in 1989 at the age of 92. Bud Kolstad celebrated his 98th birthday in 2012.

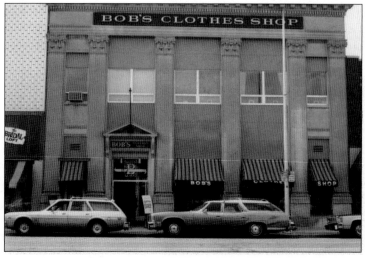

CARL WOLD. A new building for the *Park Region Echo* was dedicated on July 3, 1920, with the unveiling of a plaque recognizing Carl Wold for his editorial work with the Nonpartisan League. The newspaper featured farmer and labor activities with advertisements of party members. Eve Emerson Wold was active with the Women's Christian Temperance Union, asking for all liquor signs on buildings to be removed. Fifteen bootleggers were arrested locally before Prohibition ended in 1933.

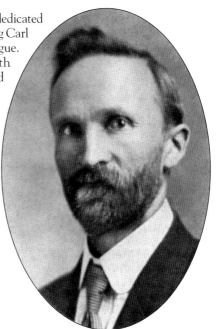

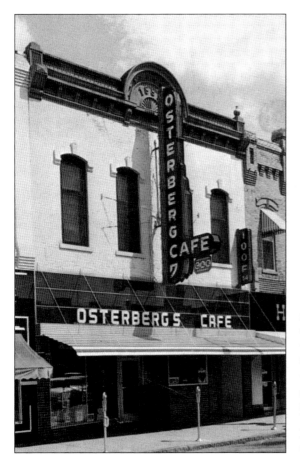

OSTERBERG'S CAFE. "Meet you at Osterberg's" was the battle cry of this well-known landmark. Richard Osterberg started the Chicago Lunch in 1921, which became a popular gathering place for kids following school events. The family restaurant business was carried on by sons Lenore, Tony, and Sonny until Osterberg's Cafe closed in 1984.

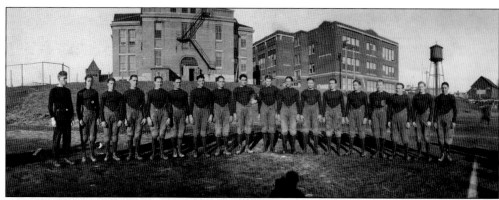

STATE FOOTBALL CHAMPIONS. The 1921 Alexandria football team beat one school 100-0 during its winning season. At some point in the championship game, Carl Johnson, a young Swedish team member, yelled out, "To hell vith the signals, yust get me the football." The buildings in the background are the 1893 Lincoln (left) and the 1915 Central School facilities.

A NEW HOSPITAL. Ed J. Tanquist, MD, purchased the L.J. Brown house on the east shore of Lake Winona in 1927, converting it to the Tanquist Hospital. An expansion in 1929 added 30 beds. In 1944, the operation was turned over to the Franciscan Sisters and given a new name, Our Lady Of Mercy (OLOM) Hospital. Dr. Tanquist convinced expectant mothers to deliver babies in the hospital, boasting that 135 babies were born in January 1948. A rival hospital, Douglas County Hospital (DCH), opened in 1955 with 52 beds; a merger created one county hospital in 1974. The OLOM building remains as a service center and office complex on Cedar Street. By 2012, DCH had become a 127-bed acute care facility serving approximately 150,000 people in west central Minnesota.

Knute Nelson. Knute Nelson came to Alexandria in 1871. His political career began in the Minnesota Legislature for two terms until he was elected as the first foreign-born governor, serving from 1893 until 1895. He then served in the US Senate for 28 years. Nelson suffered a heart attack and died on April 28, 1923, while on the train in his effort to return to his home in Alexandria. His will provided that his house be given to the Norwegian Lutheran Church as a home for the aged. The Civil War veteran was given a full military funeral procession with a caisson drawn by horses bearing his casket through the village streets to the Kinkead Cemetery. His house is listed in the National Register of Historic Places and serves the public as the headquarters for the Douglas County Historical Society.

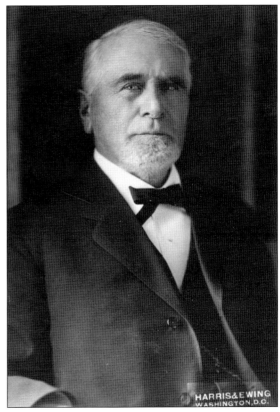

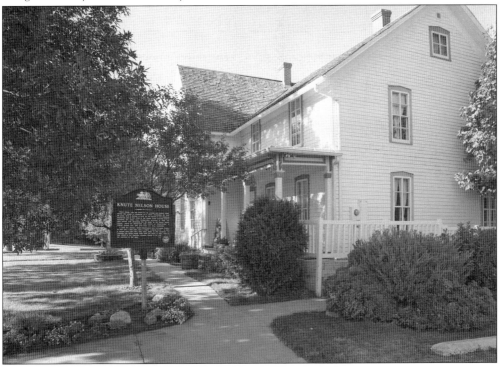

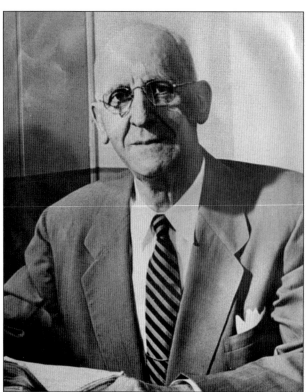

THEODORE A. "DAD" ERICKSON. Erickson is widely recognized as the founder of Minnesota 4-H Clubs, established in 1927. As a teacher and school superintendent, he wanted farm boys and girls to develop confidence. He organized school fairs, sending seed corn home with students with their promise to exhibit the finest ears at the fair. This in turn led to county and state fair exhibits. Erickson served as superintendent of 104 rural schools in Douglas County. 4-H Club members still fill the Erickson Building with exceptional exhibits during the annual fair.

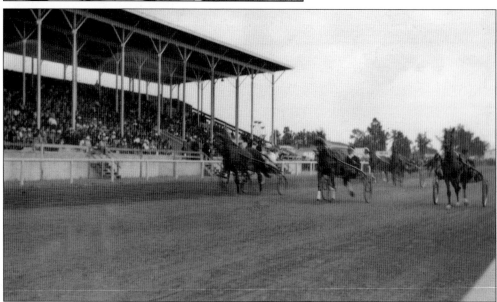

DOUGLAS COUNTY FAIRGROUNDS. Street fairs became a thing of the past in 1914 with the purchase of land west of Alexandria by the Douglas County Fair Association. Successful fairs have been held for over 100 years, surviving the Depression and war years. A large grandstand built in 1938 by the Works Progress Administration (WPA) featured an oval track used for harness racing and is still in use for stock car races, tractor pulls, demolition derby and NASCAR events, which have replaced horse racing.

COWING HOUSE. Built in 1875 on Third Avenue and Jefferson Street, the Thomas F. Cowing house is one of the oldest buildings still standing in Alexandria that retains its original design. The house is an excellent example of a Gothic Revival cottage popular in the 1850s and early 1860s. Cowing was one of Alexandria's earliest businessmen and political figures. He established Alexandria's second store and served as first sheriff and treasurer of the county, postmaster, village judge, and trustee and president of the city council in 1880. The house was sold to Gustave Kortsch in 1889. Kortsch opened a successful department store, which he sold to the Herberger-Wettelson Company in 1914.

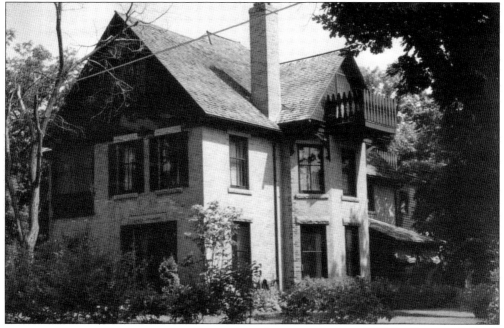

ROBARDS HOUSE. This immaculate Queen Anne home was built in 1889 for Oscar and Cecile Robards, co-owners of Cowing Robards Hardware Store, founded in 1872 during the formative years of Alexandria's commercial district. The second-generation owner of both the house and hardware store was Hugh "Pat" Robards. This private home, located at 518 Sixth Avenue West on the east shore of Lake Winona, is one of several properties within the Silk Stocking District.

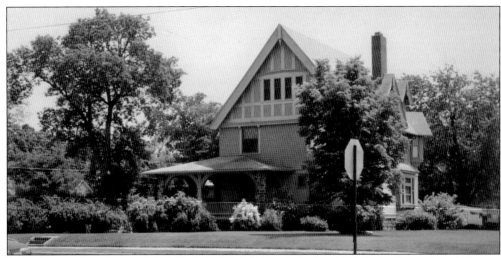

WARD HOUSE. Noah and Sally Ward were the first to own this 1903 Tudor Revival–style home. Ward owned a grocery, crockery, and provision store. In 1928, Carl V. Anderson, founder of Anderson Furniture, became the second owner. His sister Alma Anderson opened a hostess house after Carl attempted to operate a funeral home at this location. He was forced to seek a different location when public sentiment rose against a funeral home across the street from the hospital. This home is now known as Cedar Rose Inn, a bed-and-breakfast, located at 422 Seventh Avenue West.

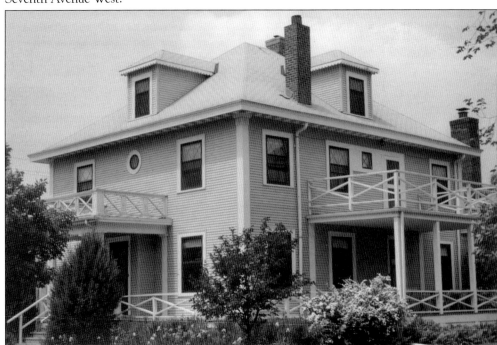

JACOBSON HOUSE. A Classical Revival–style home at 405 Seventh Avenue West was first owned by Andrew and Alta Jacobson in 1904. Andrew was a cashier at Farmers National Bank who, along with his brother Tollef, owned three other banks in Douglas County. Andrew was the first president of the Alexandria Golf Club. The second owners of this home were Arthur and Ila DuBeau, owners of Blakes by the Lakes from 1923 to 1947.

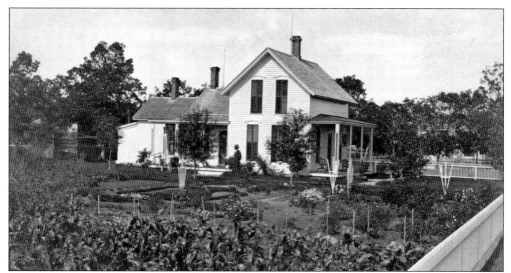

SIMS HOUSE. This wonderful house at 521 Seventh Avenue West was built in 1876 for Lorenzo and Sarah Sims. Lorenzo established the first drugstore in the village. Sarah was the sister of William Hicks, owner of most of the townsite lots. The vernacular–style home is set back from the street on a rolling hill overlooking Lake Winona. Future owners included George and Mary Robards, co-owners of Cowing Robards Hardware Store. Later, it was owned by attorney C. Fred Hanson, who initiated the GI Bill of Rights while serving as commander of the American Legion Post.

STEVENS HOUSE. A vernacular-style home at 321 Sixth Avenue West was built in 1868, the year that settlers began to return to Alexandria after it had been abandoned when the US–Dakota War began in 1862. It is one of only a handful of homes that remains from the postwar resettlement period of 1868 to 1869.

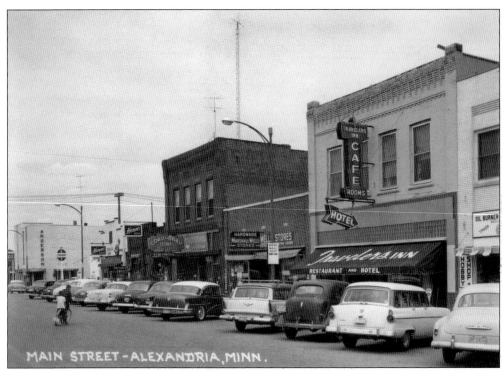

TRAVELER'S INN. This long-standing eating establishment in downtown Alexandria was opened in 1925 by Thomas and Magdalena Rose. The 1928 interior is shown on the current menu. The Roses sold the business to Harold and Lorna Anderson, who operated the restaurant from 1949 to 1960. Harold and Lucille Hansen were owners from 1960 until 1967 when Ben and Helen Sieve purchased the inn. They turned it over in 1972 to sons Jon and Kurt, who continue the tradition of a family-run restaurant. A major face-lift was done in 1996 to restore the original integrity, including uncovering the stamped-metal ceiling.

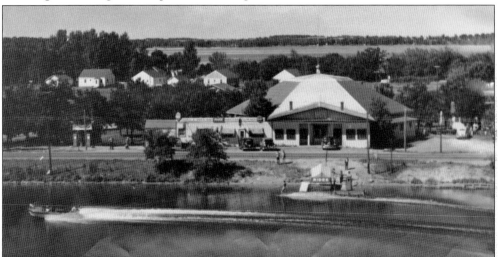

GANG PLANK. Built in 1927 by A.J. DuBeau, who operated Blakes by the Lakes, the Gang Plank was a popular dance hall and roller rink on the west shore of Lake Le Homme Dieu. In 1986, the old landmark collapsed under the weight of heavy snow, signifying the end of an era.

Kensington Runestone. There is a phase of Douglas County's European history that is said to go back to pre-Columbian days—the year 1362—that is the connection to the Kensington Runestone. County historian Constant Larson, along with 11 Alexandria businessmen, purchased the unique artifact in 1928 to exhibit at the chamber of commerce headquarters. Intriguing details of the story began in 1898 when Olaf Ohman uncovered a large stone on his farm near Kensington in the southwest corner of Douglas County. The strange carvings on the stone were studied and determined to be runic letters telling of a 1362 Scandinavian exploration to the area. In this 1921 image, Ohman is pictured with Civil War veterans and the Kensington Runestone. The Viking story plays a vital role in Douglas County and Alexandria lore.

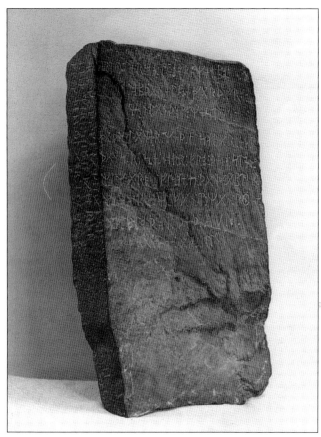

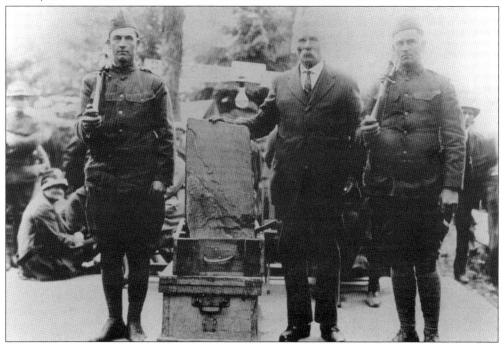

HERBERGER'S DEPARTMENT STORE. George Herberger owned his first store in the neighboring town of Osakis from 1901 until 1956. Incorporated as Herberger-Cruse Company in 1914, Herberger's of Alexandria initially opened at Sixth Avenue and Broadway before moving to 522 Broadway. The second floor held the Opera House, a cultural center for the community until the high school was built with an auditorium. Three levels of merchandise included a bargain basement department. Expansion of the company included 20 stores from 1943 to 1979 in six states. Herberger's has been located in the Viking Plaza since 1977.

PETE'S SUPER MARKET. Howard Peterson, also known as "Super Pete," opened a grocery in 1939 featuring a large fresh vegetable, meat, and grocery department. Maynard, also known as "Bud," joined his father in 1959 with a grand opening at a new location at Thirteenth Avenue and Broadway. When the Viking Plaza opened in 1970, Pete's Super Market was one of the anchor stores with a new concept: an in-store bakery. Neil Peterson is the third-generation owner, continuing 87 years of business.

ALEXANDRIA TELEPHONE COMPANY. Beginning in 1902, a small group of men living in the village of Holmes City envisioned a countywide telephone system. A fast expansion proved to be too much for the young company. In 1921, a complete reorganization took place, and the Alexandria Telephone Company was formed and became successful. The vision of the start-up group now provides local and long-distance telephone service, toll-free service, high-speed Internet, web hosting, computer protection service, digital television service, and nationwide cellular service through Gardonville Cooperative Telephone Association.

RUNESTONE ELECTRIC COMPANY. The year was 1935 when Pres. F.D. Roosevelt granted powers to bring electricity to rural areas. The Runestone Electric Association was created on May 11, 1935, to begin construction of 53 miles of power lines in rural Douglas County. It is next to impossible for people who have grown up with electric lights to imagine the deep emotion felt by farm families when their homes were first electrified. In 2012, over 13,396 accounts were served, representing farm, commercial, industrial, and irrigation accounts.

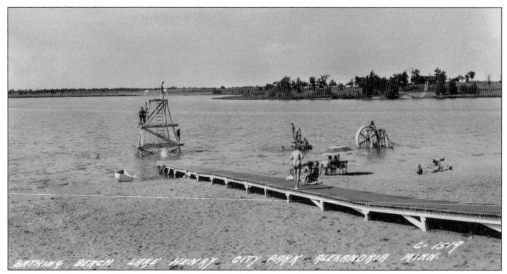

CITY PARK, 1923. Phil Noonan served with the city park department for 20 years. In 1923, he purchased eight and a half acres of land between Lakes Agnes and Henry to develop a park and swimming beach with a waterwheel. A bandstand was added in 1925. City Park remains in use for family gatherings with tennis courts, a public swimming beach, and safe access to the bike trail.

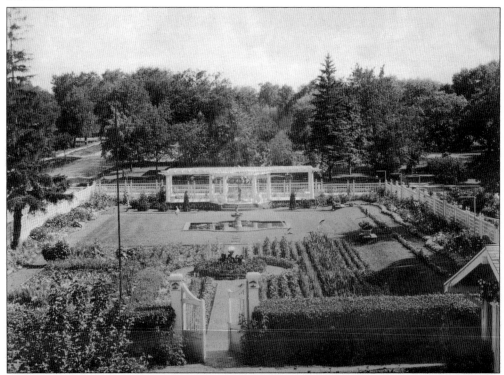

LITTLE BIT O' HEAVEN, 1934. One of Noonan's greatest accomplishments was his Little Bit O' Heaven garden. This tourist attraction was open to the public from 1934 until 1954. Visitors from every state in the union and many foreign countries toured the large garden that was located on Sixth Avenue and Kenwood Street, south of the Noonan home.

NOONAN HOUSING DEVELOPMENT, 1936. Great pride in his hometown led Noonan to make many contributions to the citizens of Alexandria. He conceived, planned, and erected a model section of homes in 1936, one of the first housing developments in Minnesota. Located on Maple Street, the 27 homes were constructed during the Depression as housing for his employees.

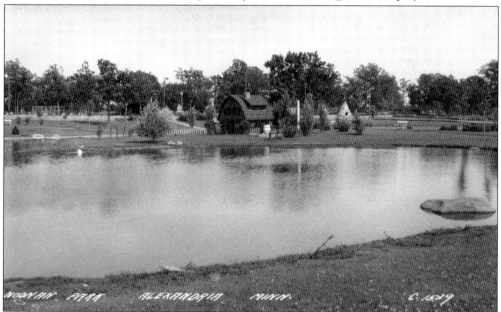

NOONAN PARK, 1937. Property on the south edge of the housing development became a park with live ducks, geese, and swans in the pond. A fairy-tale Duck Inn patterned after a house in the famous Mother Goose rhymes was built. Picnic areas and playground equipment make it a popular spot for local residents and tourists in spring and summer. Ice-skating and hockey take over in the winter season. Noonan donated the park to the City of Alexandria with the understanding that the property remain and be used for park purposes only.

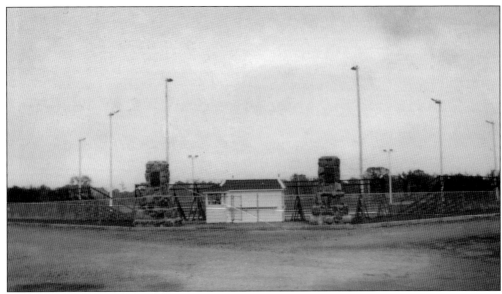

KNUTE NELSON BALL PARK, 1938. Noonan paid for plans to develop a ball field on property previously occupied by L.J. Brown Furniture Factory and Nass Tannery, and City Athletic Field opened in 1938. Named for the late Sen. Knute Nelson, the ballpark has been in use through the years as a football and baseball field. It has been home to a collegiate league baseball team, the Alexandria Beetles, since 2001.

GARDEN CENTER, 1939. Opening on July 1, 1939, Garden Center was one more contribution by Noonan to the city, with eight bowling alleys, pool, billiards, table tennis, and rifle club, as well as lunch and beverage service. Located on Hawthorne Street near the downtown business district, the bowling alley also served as a convention center and a meeting place for Rotary Club and other service organizations. Owners Leroy Meyer and family remained at the downtown site before expansion at a new location in 2005.

ALEXANDRIA AIRPORT, 1944. A field southeast of town, owned by Chris Raiter, was used as a landing strip after World War I. Establishment of a federal military airport began in 1942, with dedication of the official airport in 1944. Runway extensions were made for larger aircraft and jet planes, along with improvements to hangars, terminal, and lighting. Harold Chandler was named airport manager in 1962. The full-service facility offered pilot and flight instruction. Chandler retired in 1973 but continued flight instructions until 1979. Chandler Field was dedicated in 1978.

WELCOME CENTER. A small stand in the middle of the Broadway and Third Avenue intersection provided information from the chamber of commerce to 3,337 tourists in 1942. The local newspaper, the *Park Region Echo*, reported that the small center was a target for "getting smacked by turning traffic," almost on an annual basis. In 1953, a cement truck and taxi wrecked the sides and the new sign.

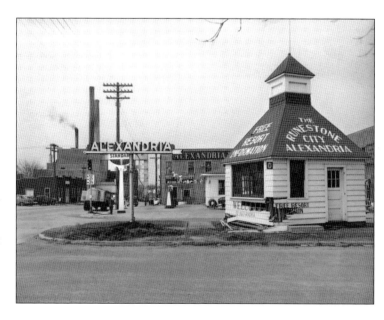

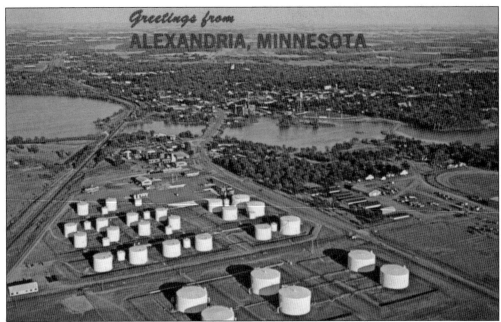

GREAT LAKES PIPELINE. Great Lakes Pipeline, located on Third Avenue West, opened in 1948. Williams Brothers Company purchased the tanks in 1966. A $500,000 blaze was the news feature of the year in 1978 when one storage tank containing 210,000 gallons of fuel was apparently touched off by lightning, sparking one of the most spectacular fires in the history of Alexandria. Everything was in favor of the firefighters; an east wind blew flames away from nearby tanks and rain kept tanks cool and the fire from spreading. Magellan Pipeline LP took over the operation in 2005.

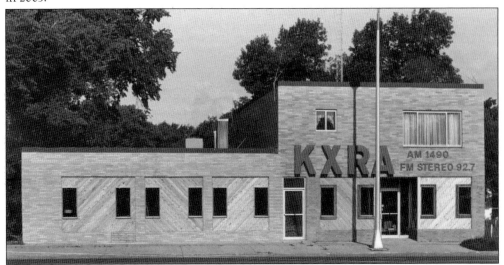

KXRA RADIO. An idea conceived by a group of Alexandria businessmen came to fruition in 1949 when KXRA first went on the air, serving as a commercial medium providing public service programming. One memory of local sports coverage occurred during the annual Resorters Tournament, when announcers Erc Aga, Cap Paciotti, and Poik Weatherwax provided a hole-by-hole commentary. Radio listeners not familiar with these colorful personalities enjoyed the commentary. *Open Line* remains a popular daily program, providing interaction with listeners.

Four

THEN AND NOW

The old town has finally become a city, with industry replacing what was once a tourist center. No matter which direction one travels out from the city, new additions have sprung up. Many new faces and names have replaced the old, with second, third, and now fourth generations taking their places. Decisions are still made by ordinary citizens elected to the city council, school board, and county commission; these decisions are not always easily accepted but are worked out through good neighbor policies. Education continues to have a high priority for Alexandria. During the 1958–1959 school year, there were four Alexandria schools in operation: Jefferson High School, Central Junior High, and Lincoln and Washington Elementary schools. District No. 206 expanded in 1974 with the addition of Garfield, Carlos, and Miltona Elementary schools. Voyager Elementary was built in 1988, Discovery Middle School in 1994, and Woodland Elementary in 2010 to replace Washington. The opportunity for learning extends beyond the city limits with the Alexandria Technical and Community College currently serving over 4,000 students.

Outstanding medical facilities offer a wide range of care, drawing people from throughout the state. Longevity is evident in many of the local businesses as family ties bring young people back home. Several early merchants have upgraded, enlarged, switched places or moved to a new location in much the same manner as the city founders. Two events that significantly impacted Alexandria were the arrival of a local television station in 1958 and the opening of Interstate 94 in 1967. The city limits were expanded to the south, adding 1,468 acres to the city. Minnesota Highway 29, the main road north and south, was reconfigured to create a new route around the Chain of Lakes. The old scenic route became Highway 42. Road improvements and changes were discussed, redrawn, and built for the expansion of new homes around the lakes.

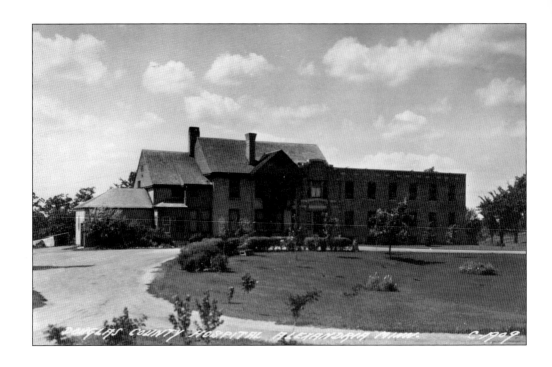

OUR LADY OF MERCY HOSPITAL. At the request of Dr. E.J. Tanquist, the Franciscan Sisters took over the operation of the Douglas County Hospital in 1944. The name changed to OLOM in 1955 when a new facility was built on Cedar Avenue. It continued service until 1974, when a merger with the south hospital closed this hospital, and its rooms were converted to office space.

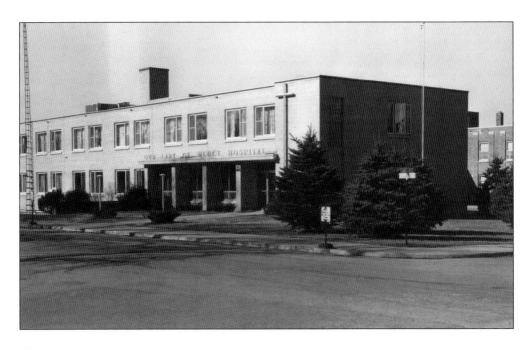

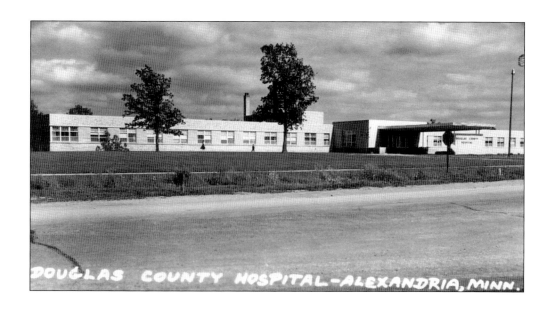

DOUGLAS COUNTY HOSPITAL. Built in 1955, a second hospital, Douglas County Hospital South, opened on Sixteenth Avenue and Broadway. A religious affiliation issue was resolved in 1974 when all services were brought under one roof at the Broadway location. Enlarged and expanded over the years, the 127-bed acute care hospital currently serves 150,000 people in west central Minnesota. An 110,000 square foot addition in 2010 includes the Heartland Orthopedic Specialists clinic, a new main entrance, lobby, patient rooms, and an obstetrics unit.

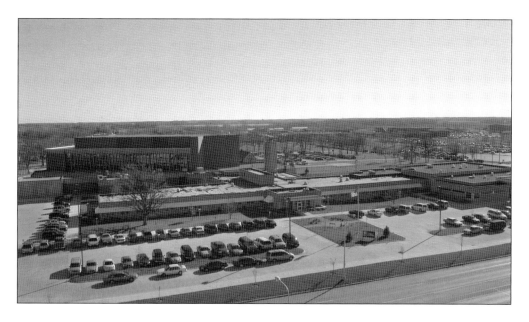

ALEXANDRIA CLINIC. This clinic was founded in 1945 by Drs. George W. Clifford, C.E. Carlson, Harold Stemsrud, and L.F. Wasson; they were later joined by Drs. Douglas Perkins, William Heegaard, Peter Geiser, and Vernon Kuhlmann. The original clinic was built in 1955 on Fillmore Street West. Moved to 610 Thirtieth Avenue South in 1997, the clinic is dedicated to providing preventive, interventional, and supportive services in the most compassionate, thoughtful, and efficient manner.

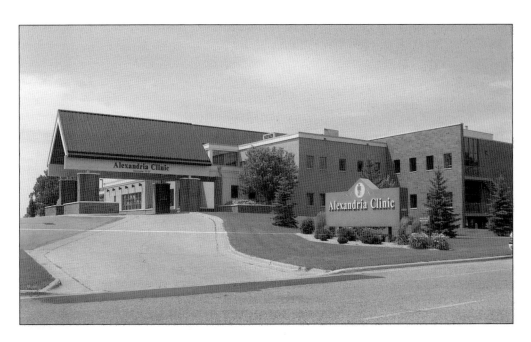

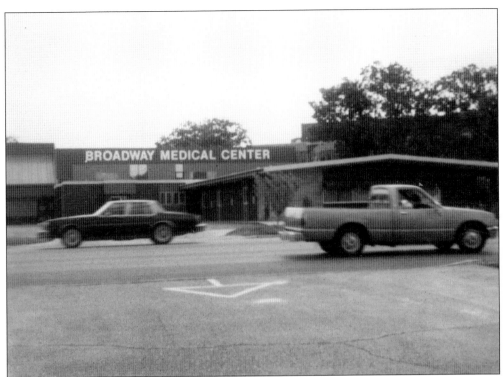

BROADWAY MEDICAL CENTER. Runestone Medical Center adjacent to the Douglas County Hospital was established in 1964 by Drs. E.J. Tanquist Sr., E.J. Tanquist Jr., and James Reinhardt at 1523 Broadway Avenue. Later, the name changed to Broadway Medical Center; it is currently Sanford Medical. The mission is "to provide compassionate care, serve our community and respect each other as family."

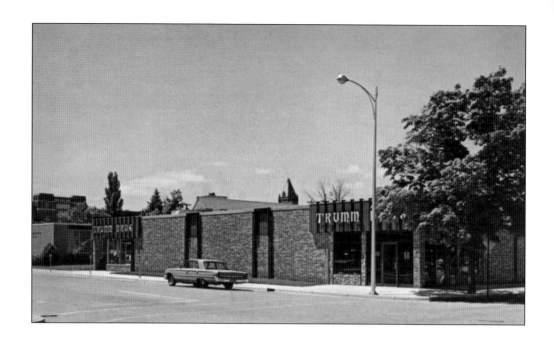

TRUMM DRUG. Archie and Clara Trumm arrived in Alexandria in 1952 and purchased Lewis Drug. They joined the ranks of Holverson Drug, Peterson Drug, and Boston Rexall Drug, other druggists who were located on Broadway. Trumm moved to the present location at 600 Fillmore Street when sons William, or "Bill," and Jack Trumm entered the family business. They were later joined by a third generation: Paul, Mark, and Greg Trumm. The store also offers medical equipment and a wide variety of gifts.

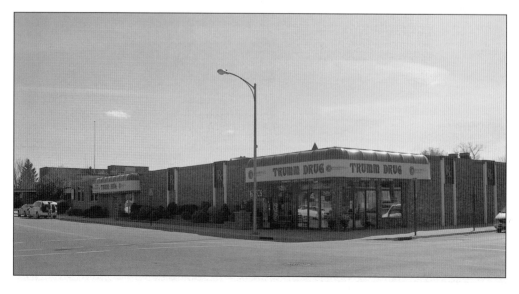

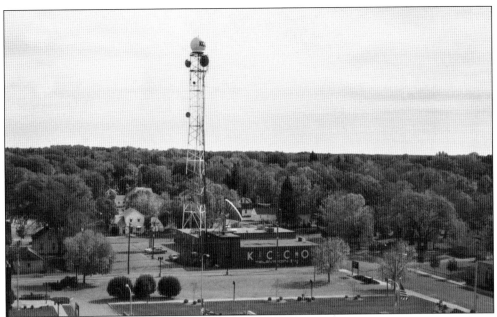

KCMT AND KSAX TELEVISION STATIONS. KCMT television went on the air for the first time on October 8, 1958, with a telecast of the World Series on NBC. Local coverage with quality reception was welcomed in this rural area. WCCO, the parent company, took over the operation of KCCO in 1987, continuing local broadcasts until 2002. A popular holiday fundraising program, *Jingle Bells*, originated with KXRA radio, and was then televised by KCCO and continued by the second television station, KSAX, which began local broadcasting in 1987; KSAX went off the air in 2012. Civic involvement and training new anchors were strong attributes of both entities.

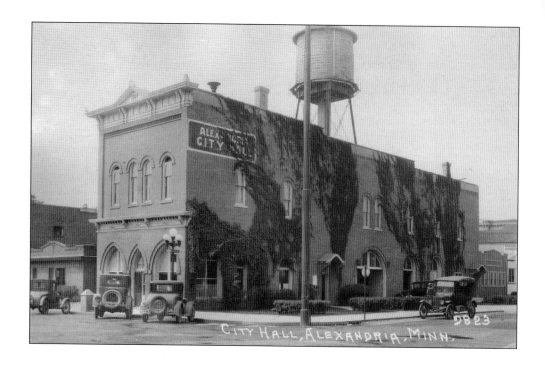

CITY HALL AND FIRE AND POLICE DEPARTMENTS. Three departments shared this building (above), erected in 1882 on the corner of Broadway and Seventh Avenue. A tangle over location followed, with city hall moving to the Geske Building and the fire and police departments remaining on the corner site. City hall now occupies a new building situated at the original spot (below).

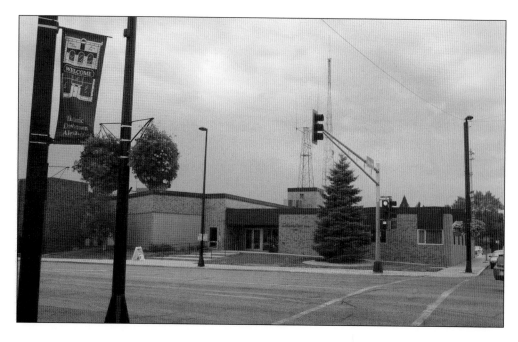

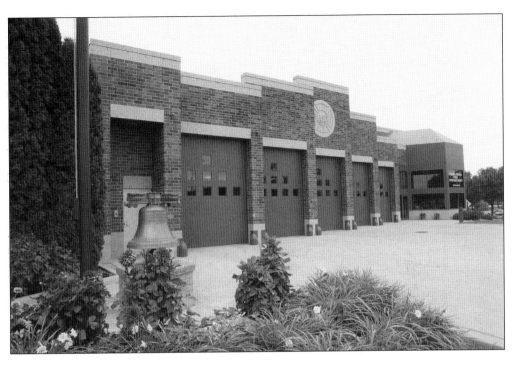

CHANGING LOCATIONS. A new facility for the fire department was built in 1994 at 302 Fillmore Street. The old fire bell is proudly displayed at the entrance. The police department relocated to Third Avenue West, adjacent to the new Douglas County Jail, built in 2011. (Both, courtesy Daniel Broten.)

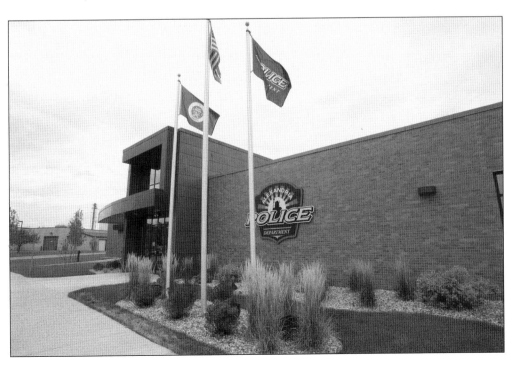

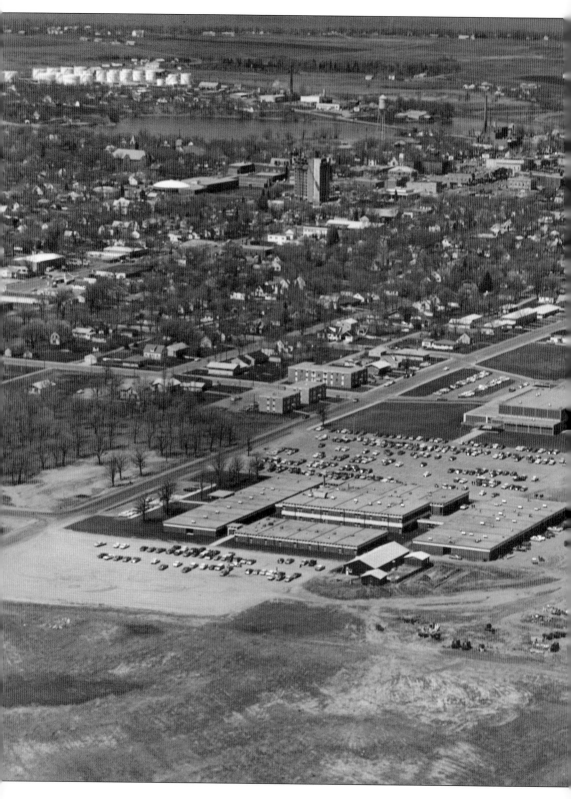

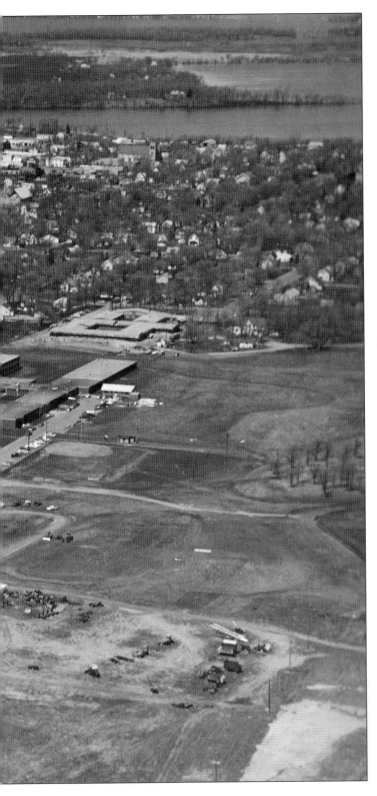

ALEXANDRIA SCHOOLS. Jefferson High School was built in 1958 on a 45-acre site along Jefferson Street. Citizens Field, a football and track arena, was sponsored by a community effort. A new high school is planned for 2013 at a new location. In 1962, adjacent property was developed to fulfill the vision of teacher Vern Maack to offer vocational training to students after regular school hours, teaching farm equipment mechanics, machine shop, and carpentry. Classes began with 23 students. With a solid reputation for quality instruction and service, Alexandria Technical and Community College currently serves over 4,000 students at the Jefferson Street location. The commitment to excellence is demonstrated in the consistent job placement rate of over 90 percent for its graduates.

RUNESTONE MUSEUM AND THE CHAMBER OF COMMERCE. Museum doors opened in conjunction with the centennial celebration in 1958 to preserve the heritage and history of Douglas County and its people. The namesake for the museum is the Kensington Runestone, a 212-pound stone containing runic inscriptions telling of Norse exploration to Minnesota in 1362. It is one of many exhibits that draw year-round international visitors to Alexandria. Also located at 206 Broadway is the Alexandria Area Chamber of Commerce, whose mission is to promote the Alexandria lakes area as the ultimate destination to live, work, play, and prosper thorough public promotion and member and information services. Visitors number over 15,000 annually. (Both, courtesy Daniel Broten.)

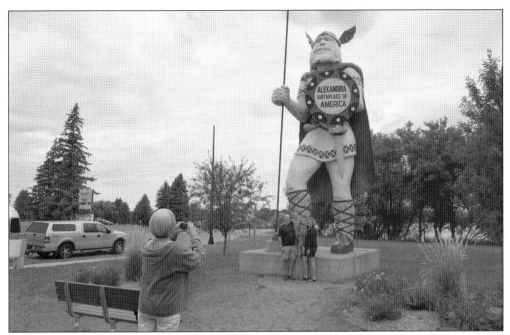

BIG OLE AND FORT ALEXANDRIA. *Big Ole* stands at the north end of Broadway near the Runestone Museum, the reference point for the Alexandria-area address system. The 28-foot-tall Viking statue weighing four tons was created to accompany the Kensington Runestone to the 1965 New York World's Fair. Fort Alexandria was added to the museum campus during the 1976 bicentennial celebration. Located on the original townsite, the replica of the 1862 fort contains authentic log buildings, an 1885 one-room schoolhouse, and a church, along with exhibits of agricultural artifacts that give visitors a chance to see the lifestyle of the first settlers. (Both, courtesy Daniel Broten.)

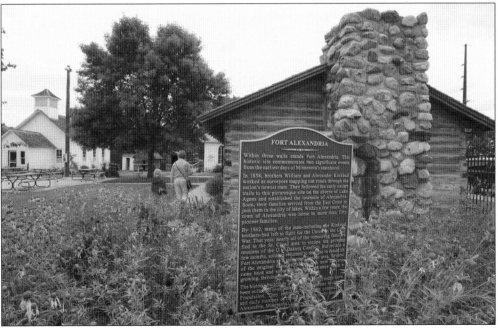

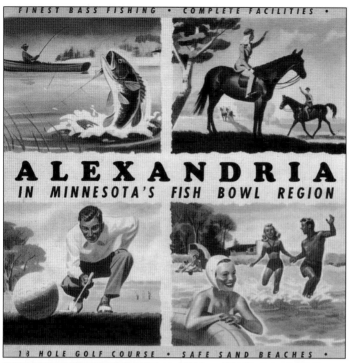

BASS FISHING. This promotion proclaims Alexandria as the "Bass Capital of the World," boasting one of the finest and most progressive resort and fishing areas in Minnesota, adding considerably to the economy of the area each year. Bass fishing tournaments are held several times during the warm months. A popular winter event is the Ice Fishing Tournament, drawing huge crowds to the frozen lakes.

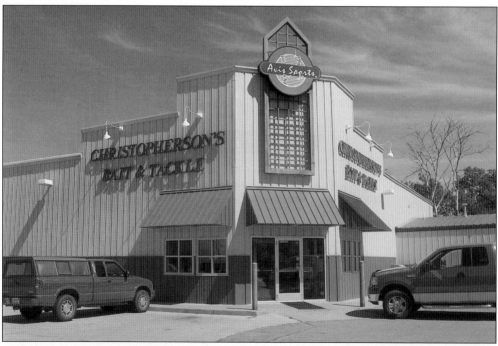

CHRISTOPHERSON BAIT. Wilber Erwin Christopherson started his bait business in 1931. He seined frogs and minnows, selling them to local resorts for 25¢ apiece. The bait and tackle shop opened at 309 Third Avenue East in 1948. The family-run business continues to serve the needs of the local fishing industry, with son Allen and granddaughter Denise and her husband, Dana Freese, as owners and operators.

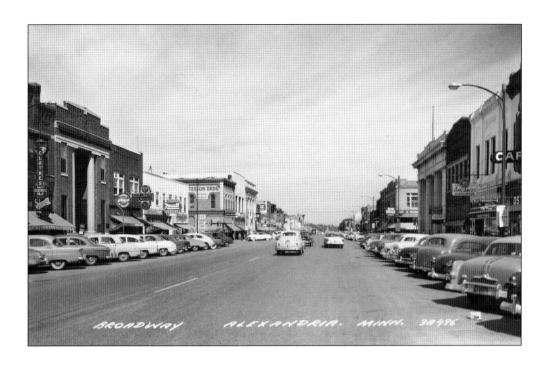

How to Park? A heated debate took place from 1957 to 1958 regarding parking on Broadway: Diagonal or parallel? Parking meters or none? The proper way to park became a bone of contention for city officials. The parking dilemma was settled by the State of Minnesota; parallel parking is the law. On the other issue, the parking meters were out and in and out again. Currently, they are still out.

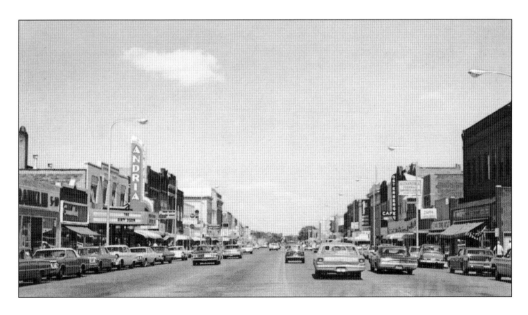

DARLING RANCH RESORT, ARROWWOOD RESORT. A 70-acre farm on the shores of Lake Darling began as a summer project in 1946 for brothers Paul and George Anderson. Offering horseback riding, they expanded as a resort with family dining, cabins, and recreation programs including golf and water-skiing. After 20 successful years, their big dream of a year-round resort had not been realized. The potential was there, but not the financial backing. In 1971, the resort was sold to investors of the Radisson Hotel Corporation, who built a year-round center called Arrowwood. The expanded property provided space for a nine-hole golf course, a marina, stables, and winter activities. Changes in ownership initiated renovation of the resort. The present resort and convention center includes a water park and other amenities for tourists.

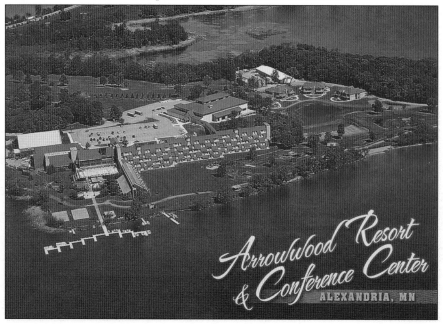

BURSCH TRAVEL. M.W. "Pete" Bursch founded a travel agency in Alexandria that has grown to 14 offices located in Minnesota, North Dakota, and Nebraska. Bursch became a bona fide travel agent in 1958. Active in civic organizations, he served as a Minnesota state senator for four years. In 1980, Fred Bursch joined his father in the business that provides access to a wide range of travel information. Its mission statement is, "We are a local family owned travel business with highly skilled consultants providing priceless advice to world-wide destinations."

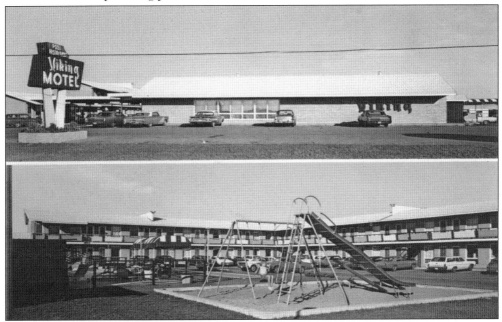

VIKING MOTEL. In 1963, a motel was constructed on Highway 29 and 27 South near the airport. The Viking Motel had 53 rooms, a public dining room for 100 people, and a banquet room offering seating for 300 customers. The outdoor swimming pool was a drawing card for the new motel. The Viking Motel Extended Stay continues to operate at the present time.

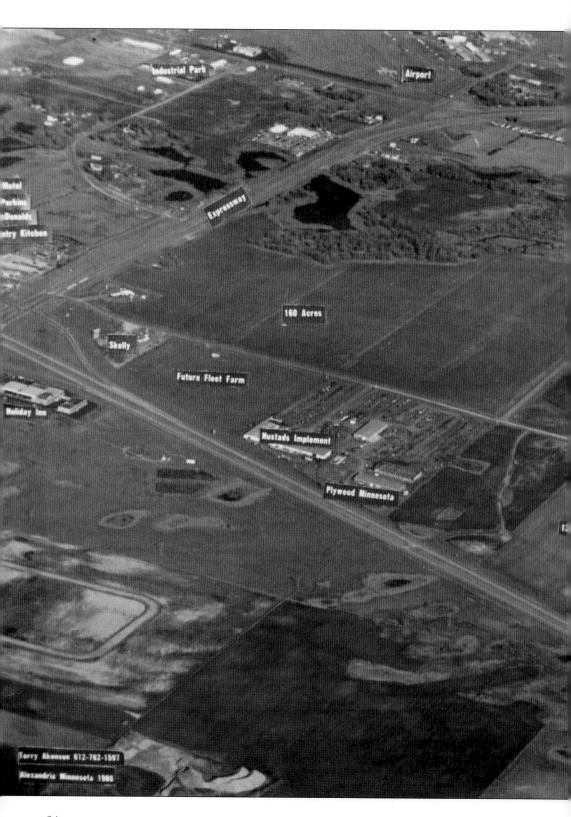

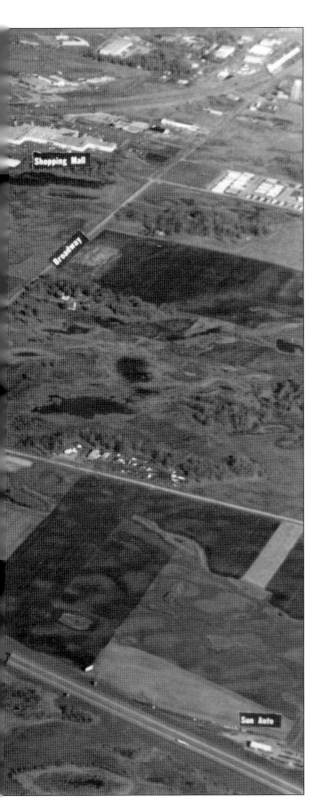

INTERSTATE 94. This 1967 overview shows new property opened for development as Alexandria continued to grow southward. Construction of superhighway Interstate 94 provided access to the Great Plains region of the central United States. The 100-unit Holiday Inn opened in 1969 at the junction of Interstate 94 and Highway 29. Additions were made in 1971 and 1997. The Viking Plaza shopping center opened in 1972 with seven businesses in 80,000 square feet. Currently, over 30 retail stores and restaurants occupy the plaza. A group of businessmen interested in the expansion of industrial business created an industrial park near the interstate highway in 1977.

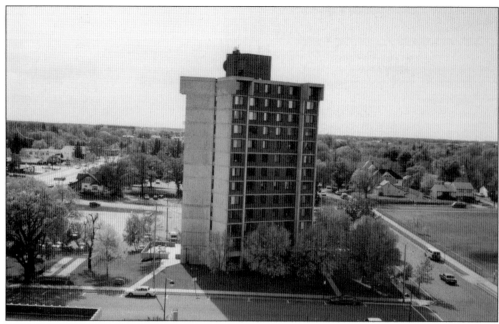

VIKING TOWERS. A 13-story, low-rent, 106-unit apartment for the elderly was built in 1970 at Eighth Avenue and Fillmore Street with financial aid from the Department of Housing and Urban Development at a cost of $1,219,300 The high-rise is the tallest building in Alexandria with the exception of the county courthouse towers.

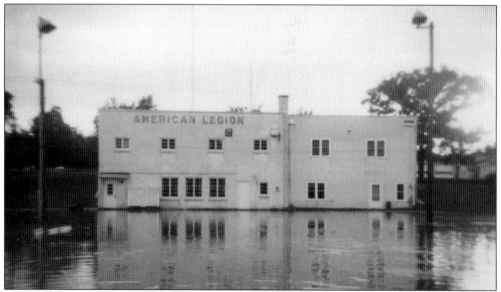

AMERICAN LEGION POST NO. 87. The American Legion Post No. 87 was chartered on August 22, 1919. Veterans of World War I converted a livery barn into a dining room and bar with headquarters for both the Legion and Forty & Eight meetings. The barn had been part of an old brewery with a stable for the horses in the lower level and the hay mow in the upper part. Built at 817 Fillmore Street, the site was prone to flooding during heavy rainfall. The Legion closed in 1995, and the property was later used by the Runestone Education District. The building was demolished in 2011, clearing space for Viking Towers tenant parking.

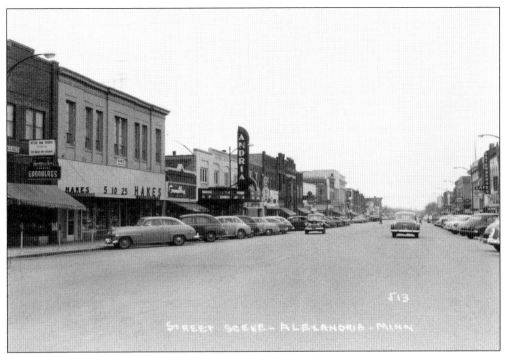

ANDRIA THEATER, CINEMA 9. The Baehr Building at 618 Broadway was purchased in 1936 by Andrew Jacobson, banker, and Eva Baehr, owner. The 800-seat Andria Theater opened on February 7, 1936, featuring the movie *Three Kids and a Queen*. Baehr sold to Joe Perino, Kenneth Bechtel, John McCarten, and Ray Vanderhaar, partners in Tentellino Enterprises in 1958. The next-door Gamble Store was converted to a smaller theater, giving patrons a twin-theater option. Movies continued to be enjoyed at the downtown location until 1972 when a new theater was built on South Broadway near the Viking Plaza. Nine screens now offer a wide variety for movie fans. Popcorn remains a favorite treat.

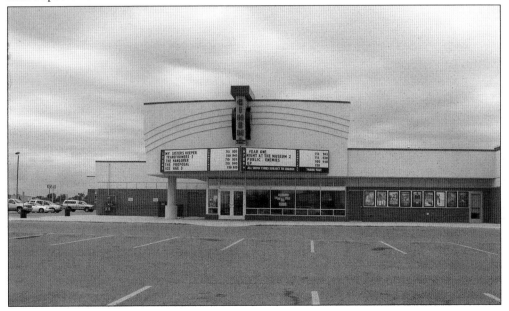

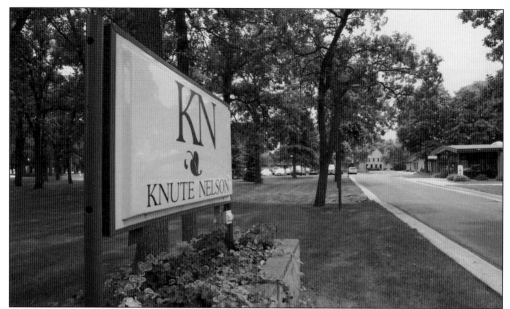

KNUTE NELSON. The homestead of Knute Nelson was given to the Norwegian Lutheran Church as a home for the aged, as stated in his will. Opened in 1948 for 10 male residents, the facility has expanded several times, in 1958, 1970, 1976, and 1986, with total capacity for 124 residents. Room for expansion in 1985 required that the original Knute Nelson House be moved. Cut in two sections for the move to 1219 Nokomis Street, the house now serves as headquarters for the Douglas County Historical Society. (Courtesy Daniel Broten.)

NELSON GABLES. Located at 1220 Nokomis Street on Knute Nelson's homestead, the assisted-living facility offers a new option for seniors 55 years of age or older. A total of 59 private apartment units create a homey atmosphere where residents receive personalized care. The Governor's Room is used for church services and is available for community events and meetings. (Courtesy Daniel Broten.)

GRAND ARBOR. A senior-living community opened in 2011 in a rural setting, 4403 Pioneer Road South East, offering apartments, assisted-living apartments, enhanced assisted-living apartments, memory-care suites and a Wellness Center, is part of the commitment made by Knute Nelson to the care of "the aged." (Courtesy Daniel Broten.)

THE FOUNDER. This plaque in the lobby of Grand Arbor defines the mission, the vision, the heritage, and the founder of the three facilities that bear the name of Knute Nelson, the "Grand Old Man." (Courtesy Daniel Broten.)

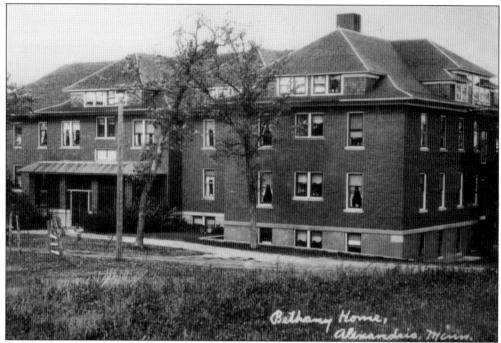

BETHANY HOME. A home for elderly residents opened on the shore of Lake Winona in 1916, sponsored by the Board of Charities of the Red River Valley Conference of the Swedish Lutheran Church. The name Bethany was inspired by the village where Jesus rested with his friends. Bethany Home continues to promote active, successful aging through the homelike atmosphere currently serving 259 residents in long-term, short-term, and rehabilitation care levels.

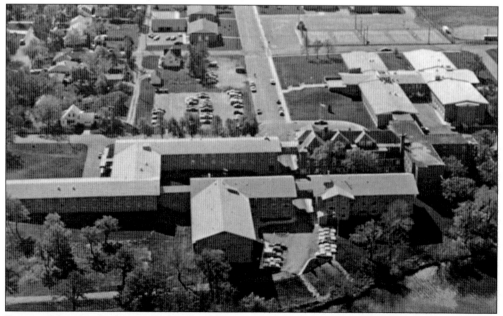

BETHEL MANOR. Built in 1974 with additions in 1977 and 1980, Bethel Manor I and II and Winona Shores apartments are independent-living facilities offering "housing with services" for seniors ages 62 and over.

Five

ALEXANDRIA PLAYS, ALEXANDRIA WORKS

To be a town without culture would be rather dull. There is no shortage of opportunity to enjoy the arts, read good books, attend a concert, golf, bowl, or play baseball, swim or ice-skate, and bike or snowmobile. Work and play sometimes go hand in hand, as documented in the local paper in 1955. Fire chief Conrad "Connie" Lund was chosen as state president of the Minnesota Fire Department Association. His nondescript 1938 fishing car was reported as stolen. A daylong search by Lund and the police ended when an urgent fire call brought the chief panting up to the fire hall; there, he found his beloved fishing car painted a shiny fire-engine red, complete with flashing lights and "Alex Fire Department" on the door, fit to lead the department to the state convention.

Alexandria has numerous eating establishments available, offering fine dining as well as fast foods. Shopping for fine clothing and jewelry is a drawing card for the city, especially during the influx of summer tourists. The downtown area is well known for antique and specialty shops. The town's citizens work diligently, with diverse job opportunities available, and employment holds at a high level. One example is Donnelly Custom Manufacturing Company, established in 1984, whose 220 employees are dedicated to setting the standard in the custom injection-molding marketplace; the company is recognized as a leader in the plastics industry. Another business started in 1972 when Ramon Nelson used salvage material to fashion a pedestrian bridge for access over the Long Prairie River to his home north of Alexandria. Continental Bridge Manufacturing, a product line of Contech Inc., is now a leader in the manufacturing of bridges, which have been shipped to all 50 states and many countries, providing access on golf courses, parks, and trails. The Alexandria Economic Development continues to encourage new industry. Over 235 companies provide a diversity of products and services. The Alexandria region is home to five of the world's leading automated packaging machine–manufacturing companies. Economic stability and continuity of family-owned businesses exemplifies the town's strong work ethic.

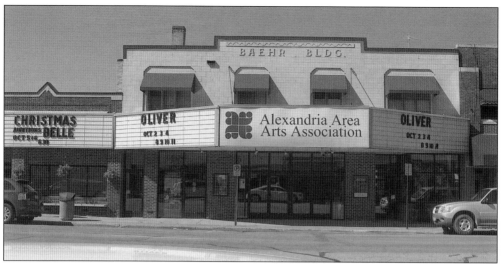

ALEXANDRIA AREA ARTS ASSOCIATION. Opening night in 1970 with hometown talent presenting *Oklahoma!* was the beginning of a successful run for the arts community. An every-other-year production presented in the high school gym drew huge crowds. Incorporated in 1974, the Alexandria Area Arts Association (AAAA) involved volunteer cast members, musicians, and stage crews. Shared space with school activities created a need for an independent facility for the arts group. The empty Andria Theater on Broadway was purchased in 1990, enabling more shows and presenting four main stage productions a year, as well as multiple visiting performers.

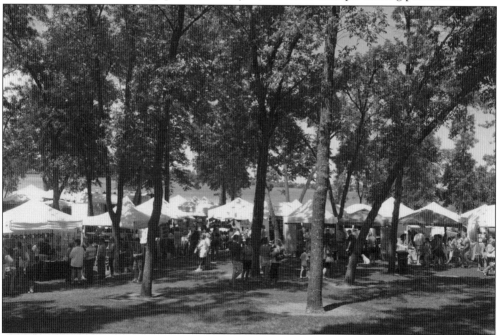

ART IN THE PARK. A showcase for artists was established in the Legion Park in 1975 by Sharon and Dave Boudin, who collaborated with members of the local Brush and Palette and AAAA. Original artwork was sold in an outdoor setting enhanced with music and food vendors. The increase in number of local artisans motivated the change in location to City Park. Massive crowds anticipate the annual event, which is held on the last weekend of July. (Courtesy AAAA.)

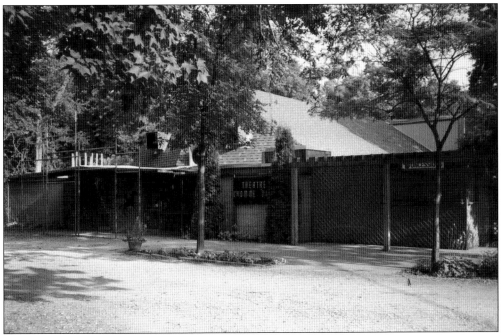

THEATER L'HOMME DIEU. A professional summer theater was founded on the Miller Cottage property on the north shore of Lake Le Homme Dieu through a collaboration between St. Cloud State University and Alexandria residents. Theater students studied with professional directors to produce shows during July and August for more than 50 years. A new format started in 2011, offering rotation of professional groups who present five comedies and musicals. The summer theater adds to the cultural climate of Alexandria.

FAT DADDY'S AT GARDEN CENTER. The grand opening of the new Garden Center was held in 2005, when proprietor LeRoy Meyer turned over ownership to his son Charlie, daughter Susan, and grandsons Chad and Matthew. The large bowling center, pro shop, arcade, the Broadway Ballroom, and a restaurant, Fat Daddy's, attract customers and bowlers from around the state to the Thirtieth Avenue and Broadway location.

LAKES AREA RECREATION. Providing a wide variety of recreational and family activities for youth and adults in Alexandria and Douglas County since 1989, the recreation center offers swimming, weight lifting, cardiovascular fitness, aerobics, gymnastics, youth camps, and a wide variety of sports. Staff schedule all other gymnastic and outdoor facilities owned by School District No. 206 and provide lifeguard services for the Lakes Latoka and Le Homme Dieu Beaches.

RUNESTONE COMMUNITY CENTER. Owned and operated by the City of Alexandria, the Runestone Community Center (RCC) opened its doors in 1977 as an indoor hockey arena. Now it is home to School District No. 206 boys' and girls' hockey teams, Alexandria Area Hockey Association, Alexandria Figure Skating Club, Vikingland Curling Club, and the Alexandria Blizzard NAHL junior hockey team. RCC also hosts many community events and conferences.

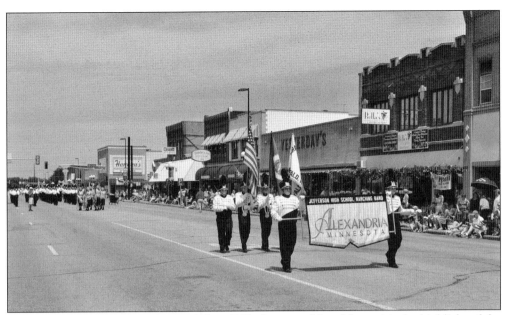

VIKINGLAND BAND FESTIVAL. Founded in 1985, the annual band festival is the highlight of the summer parade marching season. The event has drawn 85 different bands from seven states, two Canadian provinces, and Norway. Approximately 20,000 spectators line Broadway to watch the 2,000 marching band participants, some of the Midwest's finest bands that compete in this championship event. (Courtesy Scott Keehn.)

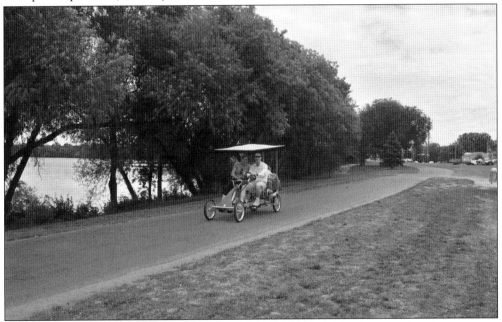

CENTRAL LAKES TRAIL. Big Ole Central Park is the trailhead for this paved and picturesque 55-mile-long trail for nonmotorized uses. Built on the former Burlington Northern Railroad line, the trail connects to other state trails, providing users with approximately 130 miles of high-quality trails. The Douglas County Trails Association maintains over 370 miles of snowmobile trails, connecting every community in the county. (Courtesy Daniel Broten.)

ALEXANDRIA AREA YMCA. This nonprofit organization opened a state-of-the-art program center on June 1, 2010, with a vision to be the leader in health and wellness and youth and family programming. The YMCA stands for youth development, healthy living, and social responsibility. (Courtesy Daniel Broten.)

MINNESOTA LAKES MARITIME MUSEUM. Following the design of the 1893 Geneva Beach Hotel, this museum chronicles the lake history of the area. Opened in 2005, exhibits include Alexandria Boat Works, the wood boat–building industry of Eric "Boat" Erickson, Chris-Craft, Garfield "Gar" Wood of Osakis, and Larson Boat Works of Little Falls, vintage fishing gear, and a salute to fishing guides. A vintage launch that belonged to Andrew Carnegie, the *Dungess*, is on display. A lakeside garden opened in 2011. (Courtesy Daniel Broten.)

CARLSON MUSIC CENTER. Sidney Carlson shared his musical heritage as band director for several Minnesota schools before he purchased Langbell Music Store in Alexandria in 1948. Current owner Ron Carlson began working with his father at 630 Broadway store in 1980. He painted the piano keyboard still visible on the exterior wall. Carlson Music strengthened area band and orchestra programs with a complete line of instruments. The center moved to 901 Broadway in 1999, giving more emphasis to piano sales. (Courtesy Daniel Broten.)

RANDY'S MEN'S WEAR. Randy Spoden managed Matzroth Clothing in the Viking Plaza from 1977 to 1981. Randy relocated to Fourth and Broadway in 1999 before moving to the Carlson Music location in 2006. Rental of formal wear for weddings and proms is good business, but Spoden is quoted as saying, "I've sold socks and underwear forever." (Courtesy Daniel Broten.)

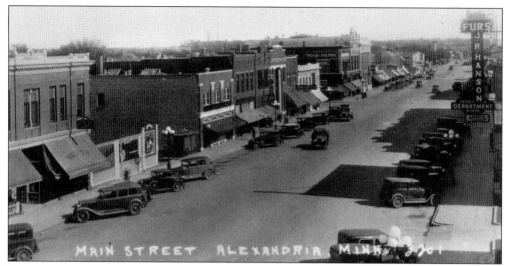

BARTHELEMY FURRIERS. J.R. Hanson opened a fur shop in the second floor of his furniture store in 1919, selling to Leo Barthelemy in 1927. Moving to the spacious basement, Leo and his brothers Cecil, Felix, and Dick created fur merchandise from ranch-raised mink and 40 kinds of fur, including Persian lamb, seal, and muskrat. Their fur business closed in 1979, when the Bathelemys retired.

JEWELRY STORES. Four Alexandria jewelers continue a tradition as all remain in business. Hedine Jewelry started in 1922 with Leander Hedine and his son Einar (then third generation), John L. (now fourth generation), John T. and Paul Hedine. Paffrath Diamond Jewelers was established in 1926 by Rudy Paffrath, expanding to an Alexandria location, where he was joined by his son Lowell, then Lowell's sons Joel, Todd, and Ted, and now fourth-generation Jacob. Diekman's Jewelry was first opened in 1961 by Gordon Diekman, who, for health reasons, sold the Broadway store in 1973 to Rodney Karrow. Karrow remains owner of Karrow's Jewelry, along with his son Jeff. Kyle Diekman assisted his father in reopening at a new location on Sixth Avenue West in 1980, the second Diekman's Jewelry.

KNUTE NELSON BALLPARK. Commemorative plaques found buried in the grass near the ballpark were retrieved and reset in a new entrance gate. They read: "City Athletic Field 1938" and "Alexandria Park Board members Phil J. Noonan, chairman, Emil Gahlon, Secretary& Treasurer, Earl I. Best, Christ Fiskness, Frank Weed, assisted by National Youth Administration 1938." (Courtesy Daniel Broten.)

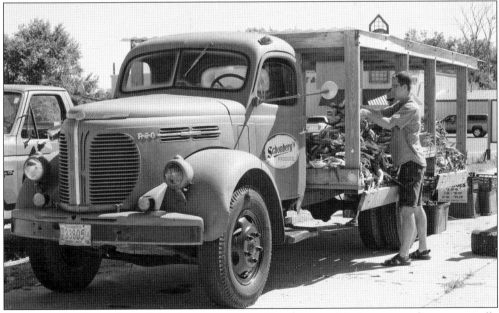

SCHONBERG'S CORN. Dave Schonberg operates a 35-acre vegetable farm, providing organically grown produce to his many customers in central Minnesota. By mid-August, the entire town waits for the sight of the green truck loaded with sweet corn, tomatoes, and other homegrown produce. (Courtesy Daniel Broten.)

SWIMMING BEACHES. There are many public beaches in the land of 10,000 lakes. Popular spots near Alexandria include Latoka, Lake Le Homme Dieu, City Park, and Rotary. Most offer lifeguard staff during the summer season.

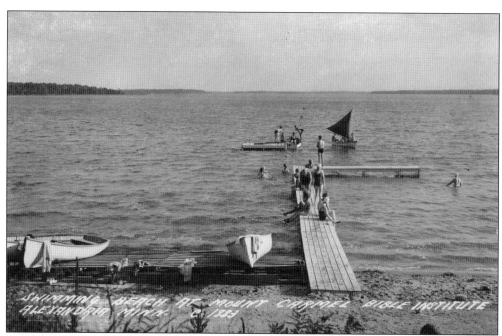

BIBLE CAMPS. Several churches have taken advantage of the beauty of area lakes to establish Bible camps: Luther Crest and Mount Carmel on Lake Carlos, Lake Geneva Camp, and Pilgrim Point on Lake Ida fill with campers over the summer.

ALEXANDRIA PARKS. City Park offers a view of the Alexandria skyline from the fishing pier on Lake Agnes. An abundance of public parks are within the city limits, including a park for dog owners. Most parks have playground equipment, picnic areas, hiking and biking paths, tennis courts, horseshoe pits, and restrooms. Carlos State Park offers campsites, hiking trails, and equestrian paths. (Courtesy Daniel Broten.)

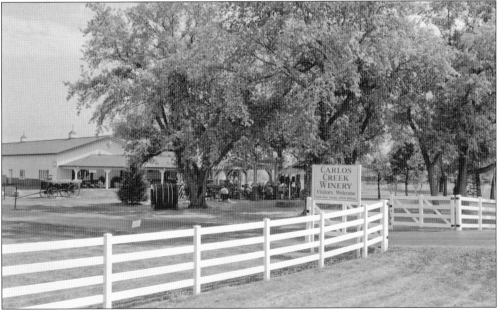

CARLOS CREEK WINERY. Minnesota's largest winery, located at 6693 County Road 34 North West, is open year-round for tours and special events, including the annual grape stomp, featuring a Lucille Ball look-alike contest. (Courtesy Daniel Broten.)

HENRY'S FOODS. Henry Eidesvold started as a candy maker in Minneapolis in 1929. His sons Harold and Lyman sold candy bars and cigarettes to grocery stores, drugstores, and pool halls. The business moved to Morris, Minnesota, and a satellite store was established in Alexandria in 1974. Ludke and Company was purchased in 1990 by Tom and Jim Eidesvold. The company is a grocery wholesaler with 175 employees and a large warehouse and office on McKay Avenue.

MINNESOTA MINING AND MANUFACTURING (NOW 3M COMPANY). This 3M division, started in 1967, manufactures abrasive belts and discs. Its 308 employees are active in community affairs and organizations. There are 214 plant locations worldwide, with products sold in 200 countries. The Alexandria plant is located at 2115 South Broadway.

ALEXANDRIA INDUSTRY. The company started in 1966 as Alexandria Extrusion with five employees in the manufacturing of precision aluminum extrusions and finished fabrications of aluminum. The plant expanded to provide solutions for customers from component design to manufacturing to assembly and delivery with 500 employees at the local plant, located at 401 County Road 22 North West.

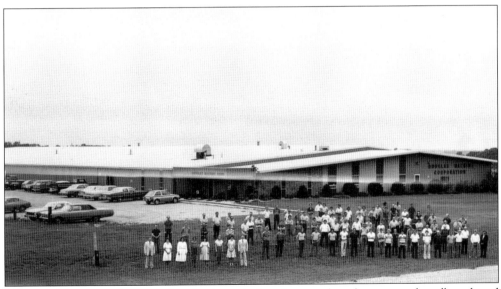

DOUGLAS MACHINE. Automated packaging solutions for paperboard, corrugated cardboard, and shrink film was developed by Bud Thoen in 1964; he was later joined by Vern Anderson as the company expanded. Located in the Industrial Park, the company is recognized as an industry leader with 597 employees.

WHOLESALE DISTRIBUTOR. H. Boyd Nelson opened a beer distribution center in the old Third Avenue brewery in 1945. Sons Rodger and Rich began a trucking business hauling product over the road from all major breweries. The two operations combined as two changes in location were made before settling at the present site in the Industrial Park.

BRENTON ENGINEERING. Established in 1987, this company, which designs and manufactures innovative case and tray packing, is an industry leader in servo-technology applications and developing integrated systems for complex packaging needs. The facility on County Road 13 employs 200 people.

ITW HEARTLAND. Keith A. Anderson founded a small machine shop in 1975. Now employing 120 workers, the company focuses on machine design, machine building, precision machining, and high torque to space ratio gears. The company has expanded with four buildings in the Industrial Park.

APOL'S HARLEY-DAVIDSON. One of the newer businesses, Apol's Harley-Davidson in the Industrial Park area, opened in 2006. It distributes, sells, and services Harley-Davidson products and parts.

ELDEN'S FOOD FAIR. Thirty years in the grocery business has been the life of brothers Dennis and Elliot Christensen, owners of Elden's Food Fair. In 1997, they purchased the Holiday Foods store on the busy corner of Third Avenue and Nokomis Street. They moved to Alexandria "because of the progressive, upbeat community, with great access to the beautiful lakes area." With a major expansion in 2012, the brothers are committed to their customers and the community.

TASTEFULLY SIMPLE. This company was founded in 1995 as the original national tasting party company. Today, Tastefully Simple is a $120 million-plus company that started when Jill Blashack Strahan used a shed in her backyard as a distribution center shared with founding partner Joani Nielson. Products are sold by independent consultants primarily at home taste-testing parties nationwide. Its headquarters are located at 1920 Turning Leaf Road, west of Alexandria, with 335 employees and more than 24,000 independent consultants. (Courtesy Daniel Broten.)

Six
ALEXANDRIA REMEMBERS

The readers of this book have traveled back in time, capturing some of the rich diverse personal stories, revealing who Alexandria is as a community. The future seems to be on a fast track for growth and expansion. How can the community keep from losing the qualities that brought it this far? People can remember, record the stories, and keep on telling them to the children. How many people know there were angels painted on a mural of the Brown's Opera House ceiling? How many even know where the opera house was located? A vivid memory for many is Andy Seegar's Popcorn Wagon, selling buttered popcorn and fresh-roasted peanuts for 5¢. The familiar church buildings remain and school bells ring, some have moved to new buildings. The lakes still fill with geese and ducks attracting children with dry bread to feed them. A look up on the walk around the town will reveal ghosts, shadows of the past. Not everything has changed—not the dates on the top of the old brick fronts, not the beauty of the architecture of the Main Street buildings, not even some of the names recalled from another generation, individuals who helped shape Alexandria.

A Chinese laundry was run by Sam Lee before 1889. Austin and Carrie Hopson came to town in 1890. She ran a laundry, and he had the barbershop on Main Street. The Hopson family file at DCHS provides details of a quote from Ione Hopson Brown, who spoke of her life in Alexandria from the time she entered school until her graduation: "I was the winner of the Declamatory Contest, but I was not able to go to the state contest because I was the only black student." Ione went on to portray the character of Aunt Jemima at public events, a role that gave her a tremendous sense of pride.

For 25 years, Clyde and Annie Newstrom, owners of a Hobby Shop on Broadway, helped and inspired 300 local boys in building and flying model airplanes. The movers and shakers of downtown recognized a need and solicited the funds for Christmas decorations or corn to feed the geese, or to help a family or business that needed a boost. Some of the first business establishments are still vital to the community. And historians preserve this valuable information for future generations.

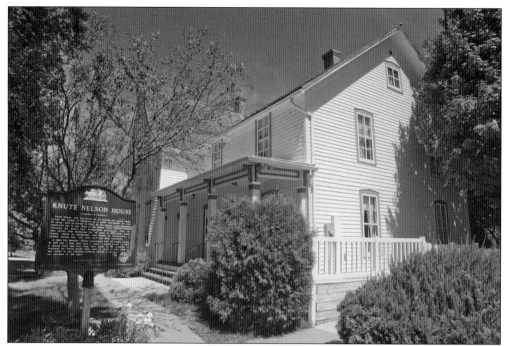

DOUGLAS COUNTY HISTORICAL SOCIETY. The historic home of Sen. Knute Nelson, located at 1219 Nokomis Street, serves as headquarters for DCHS, whose mission is "to discover, preserve and disseminate the history of Douglas County and its people." (Courtesy Daniel Broten.)

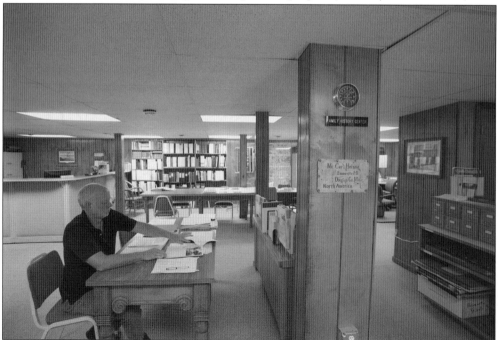

DCHS RESEARCH CENTER. An extensive library for the serious researcher includes family history files, business files, microfilm of census records and newspapers, historical photographs, church and school records, scrapbooks, and diaries. (Courtesy Daniel Broten.)

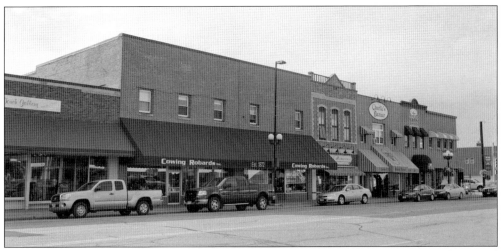

COWING ROBARDS. What was once a hardware store founded in 1872 now offers decorated apparel, trophies, and sporting goods. The oldest business in Alexandria is still located at 514 Broadway, where it was established in 1872 with the same name, Cowing Robards. (Courtesy Daniel Broten.)

ANDERSON FUNERAL HOME. The fourth generation of the Anderson family continues to serve the Alexandria area with the same sense of compassion family members have had since 1872. A new facility was built in 2006 at 920 County Road 44.

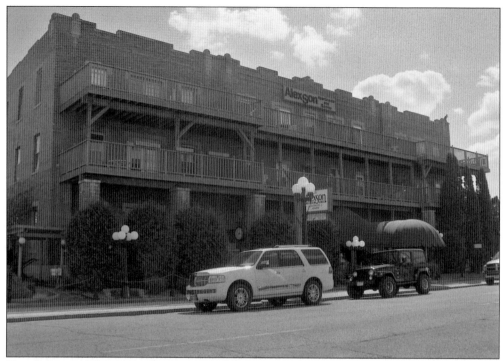

THE ALEXSON. The Letson House was built in 1880 as the tourist traffic began. The hotel has remained in operation all these years and was recently restored for rental apartments.

ECHO PRESS. Founded in 1891, the official newspaper of Douglas County continues its important role in recording and preserving history. The *Park Region Echo* and *Lake Region Press* combined as *Echo Press*, with offices at 225 Seventh Avenue East. (Courtesy Daniel Broten.)

ANDERSON FLORIST. This shop was established in 1916 by Alex Anderson at 1610 Sixth Avenue East as a small greenhouse. Four Anderson sons joined the business. Son Ardyce and his wife, Lorraine, were owners from 1950 until 1990. The new owners still use the motto "Say it with Flowers."

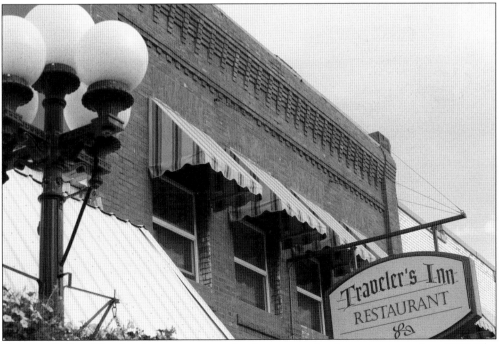

TRAVELER'S INN. This family-run restaurant has been a popular downtown spot since 1928. The Sieve family continues the tradition of good food and good service. (Courtesy Daniel Broten.)

THE INTERIOR SHOPPE. James Walker opened Alexandria's first grocery store in this 1887 building. He was the blacksmith who, in 1870, was credited with the idea for Alexandria's wide main street. Osterberg's Cafe was located here in 1921, but the site is now occupied by The Interior Shoppe, a decorating business. (Courtesy Jeff Rosti.)

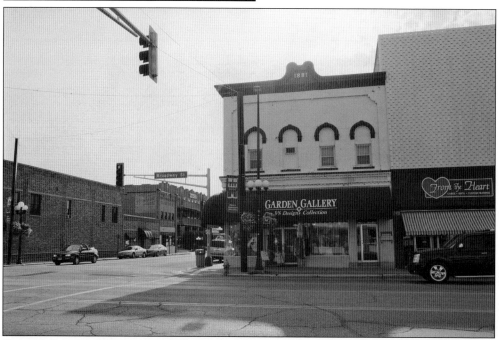

GARDEN GALLERY. Druggist C.O. Peterson was situated in this corner spot at 528 Broadway, one of the prime locations included in the hopscotching of different druggists over the years. The Garden Gallery is a clothing shop currently located in the 1881 building. (Courtesy Daniel Broten.)

ALEXANDRIA INSURANCE AGENCY. A shadow image on the brick wall indicates that George Teeson and Orie Olson built an insurance office on Sixth Avenue West in 1926. Robert Carlisle purchased the firm in 1960 and later partnered with Lloyd Andrews before the agency moved to 316 North Nokomis Street in 1968. (Courtesy Daniel Broten.)

DOUGLAS HOTEL. Another shadow image makes one wonder, "When did this hotel exist?" The answer was found in the abstract; it was a hotel on the second floor of the Loseth Building located at 503 Broadway. Tenants of the street-level store have included Montgomery Ward, Glenwear Dress Shop, Viking Saving and Loan, and Downtown Floral. (Courtesy Daniel Broten.)

MEAT MARKET. A faded image along with the 1899 date on the upper facade of the Sixth Avenue West structure provides enough clues to discover that the Ketter brothers operated a meat market here. They sold the company in 1914 to the Vennewitz brothers, experienced meat-cutters. (Courtesy Daniel Broten.)

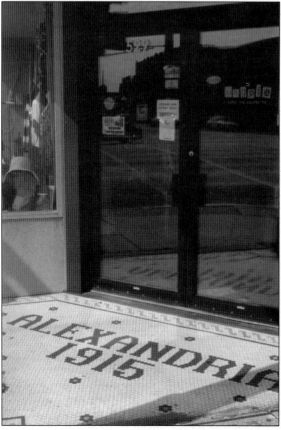

CANDY KITCHEN. Sam Caldis and John Gianopoulos, proprietors of the Candy Kitchen, were known for their homemade ice cream and candies. The tile entry dates the construction of the building as 1915. (Courtesy Jeff Rosti.)

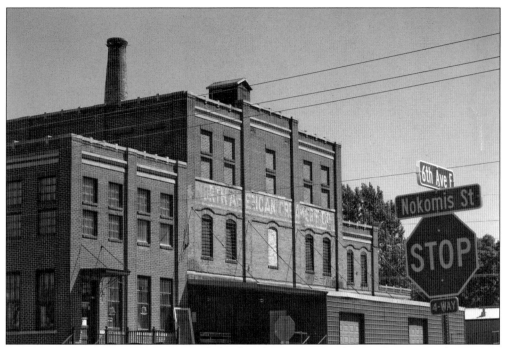

NORTH AMERICAN CREAMERY. An early landmark remains standing and in use, no longer as a creamery but a reminder of hardworking men and women during the Depression years. (Courtesy Daniel Broten.)

HUBBARD MILLING. This mill was built in 1903 for Osborne McMillan Company as a feed mill and grain elevator and was remodeled in 1948 for retail and wholesale feed and seed business. Hubbard Milling Company, a flour-milling firm, took ownership in 1965. The mill is still in business, serving the agricultural community. (Courtesy Daniel Broten.)

A Ghost Story. The funeral home owned by Edwin and Edgar Engstrom and John Maetzold from 1947 to 1971 and Tom Petermeier from 1971 to 2007 was located at 1001 Broadway. The building was demolished in 2007 to make way for a new bank. In the middle of the night, a 9-1-1 call came into the police dispatcher from the vacant lot. Arriving at the site, the police found no unusual activity. A follow-up revealed an electrical short in the old telephone lines buried under the rubble, not the work of a spirit. Mystery solved.

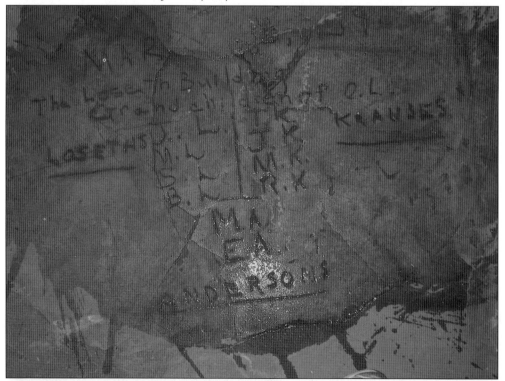

Family Tree in Concrete. A water spill in the basement of the Loseth building on Fifth Avenue and Broadway revealed an image in the concrete floor. In 1964, the building was listed in the estate of Odin Loseth as sold to son William Loseth and daughters Mary Loseth and Susan Mickelson. Etched initials in the concrete appear to be a family tree.

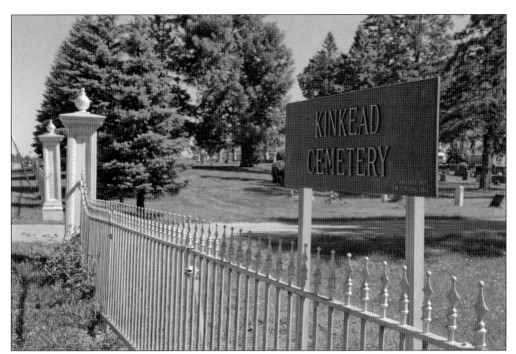

KINKEAD CEMETERY. One constant reminder of William and Alexander Kinkead, the 1858 founders of Alexandria, is the cemetery. It was platted in 1875 on property donated by William Everett Hicks. (Courtesy Daniel Broten.)

HICKS FAMILY GRAVE SITE. Members of the Hicks family were laid to rest in the Kinkead Cemetery. A marker for a trusted servant is included in the family plot. The inscription praises her: "Margaret, Well Done Thou Good and Faithful Servant." The same thing can be said about the Hickses' heritage: "Well Done." (Courtesy Daniel Broten.)

Discover Thousands of Local History Books Featuring Millions of Vintage Images

Arcadia Publishing, the leading local history publisher in the United States, is committed to making history accessible and meaningful through publishing books that celebrate and preserve the heritage of America's people and places.

Find more books like this at
www.arcadiapublishing.com

Search for your hometown history, your old stomping grounds, and even your favorite sports team.

Consistent with our mission to preserve history on a local level, this book was printed in South Carolina on American-made paper and manufactured entirely in the United States. Products carrying the accredited Forest Stewardship Council (FSC) label are printed on 100 percent FSC-certified paper.